RELATIONSHIPS

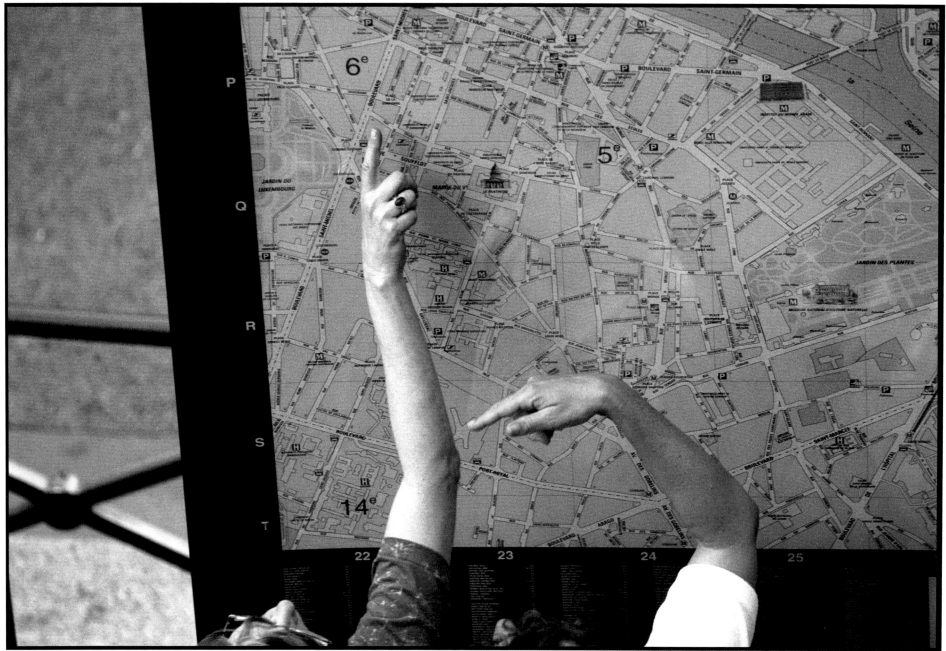

Navigating the Left Bank

RELATIONSHIPS

TERRY CARROLL

OAKLAND HOUSE PRESS

OAKLAND, CALIFORNIA

"Plantzilla" (featured on page 102) is a tribute to
the most excellent children's book of that title,
written by Jerdine Nolen and illustrated by David Catrow,
published by Voyager Books (2002),
and imitated by only the most discerning young artists.

Design, layout, and pre-production
by Terry Carroll
using Adobe Photoshop and InDesign on a Dell desktop computer
Typeface: Adobe Garamond Professional

Printed in the U.S.A.
on 100-lb. Lustro Dull White Text
using a duotone separation with a 300-linescreen output
at The Stinehour Press
Lunenburg, Vermont
www.stinehourpress.com

Limited First Edition
(750 Copies)

396/750
Terry Carroll

Published and distributed by:
Oakland House Press
Ocean View Drive
Oakland, CA 94618-1535
Orders and inquiries:
510-287-6286
house@oaklandhousepress.com

Artist's Statement & Dedication

Relationships is a manifesto of innocence and understanding, love and friendship, romance and passion, curiosity and revelation.

I present this collection of photos for and because of Linda Dardarian. My first book, it goes to print on the twenty-fifth anniversary of that exuberant night we fell in love.

Terry Carroll
January 28, 2008
Oakland, California

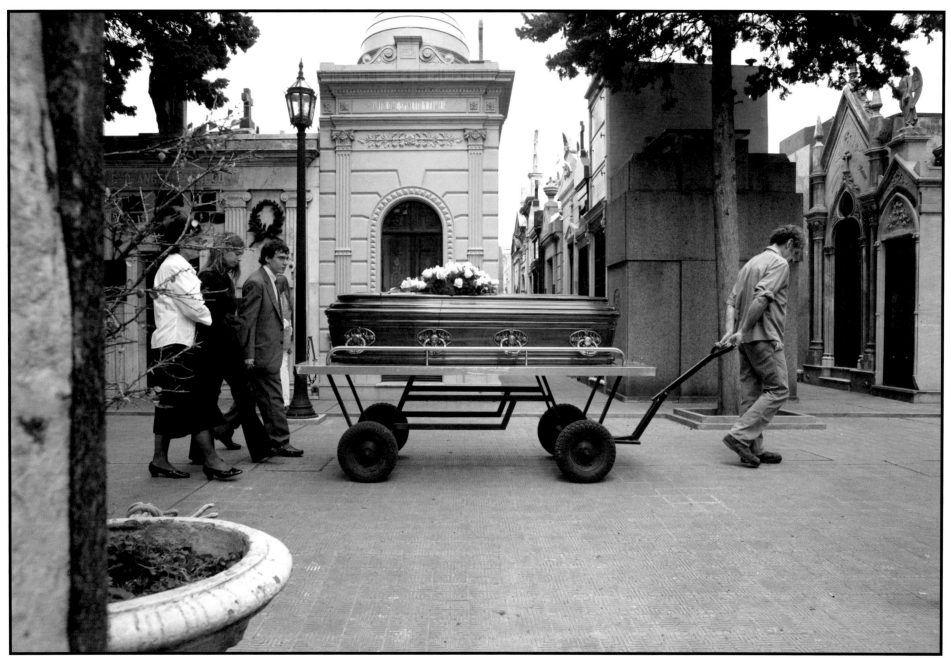

Funeral at the Recoleta

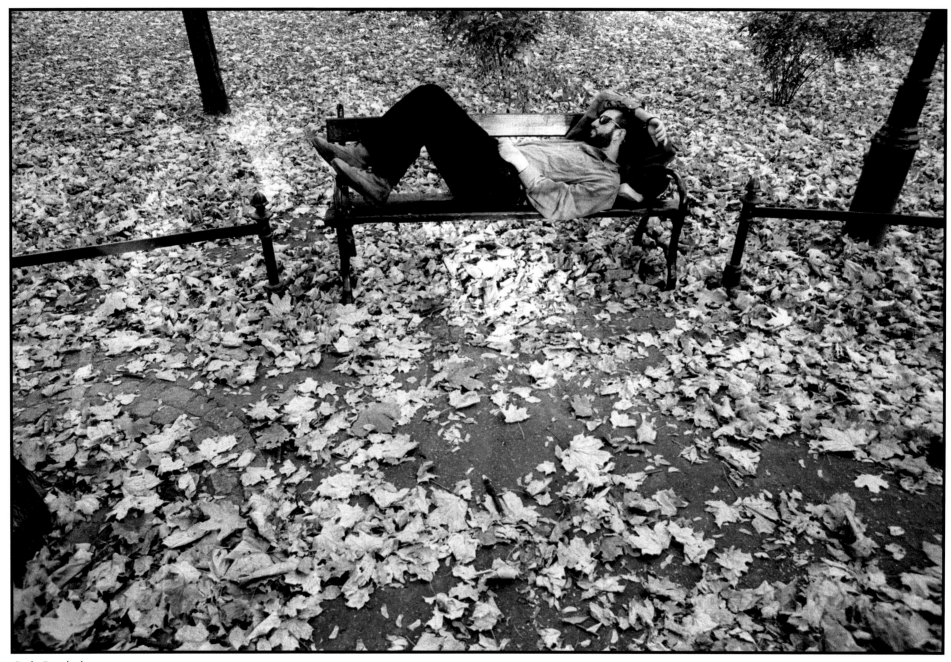

Rick, Benched

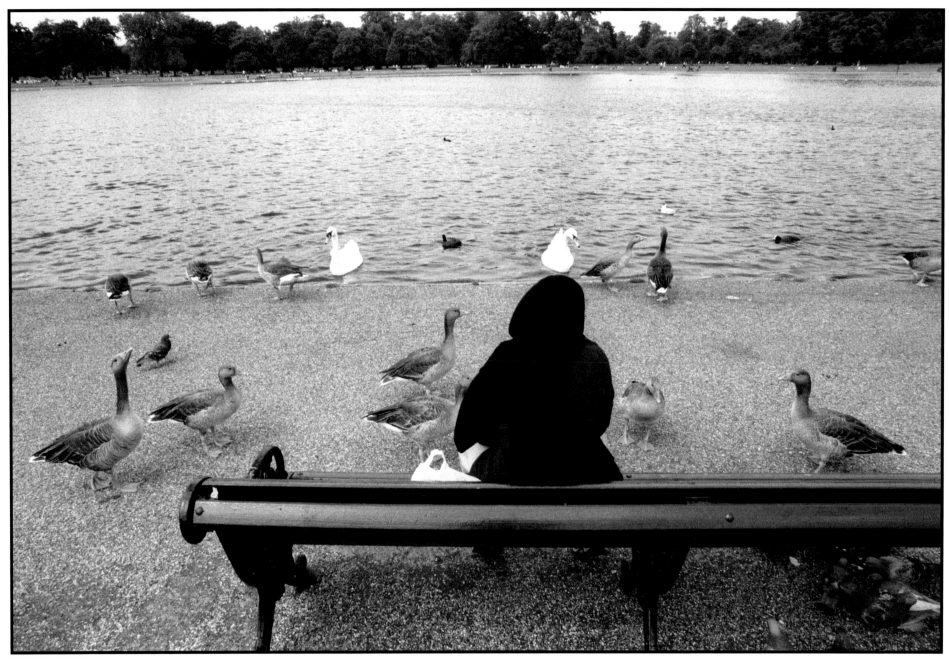

Feeding Fowl

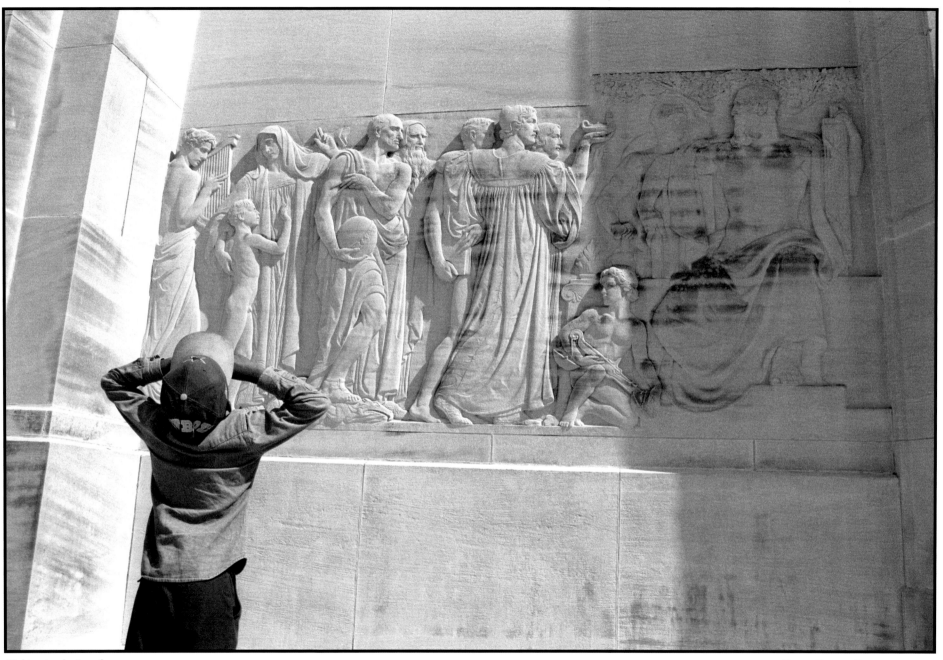

Taking in the Statehouse

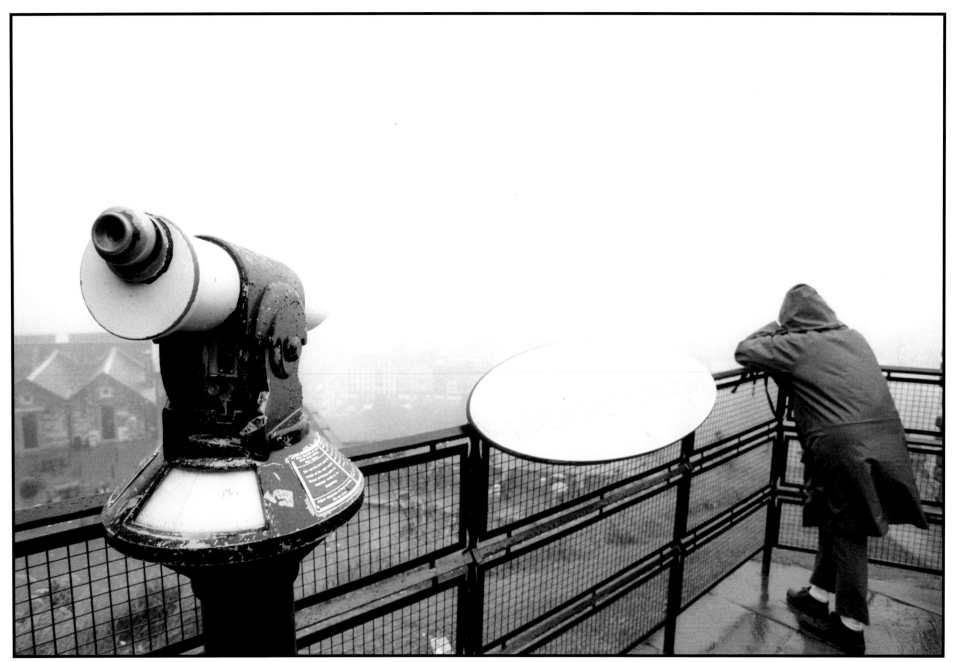

View of Edinburgh

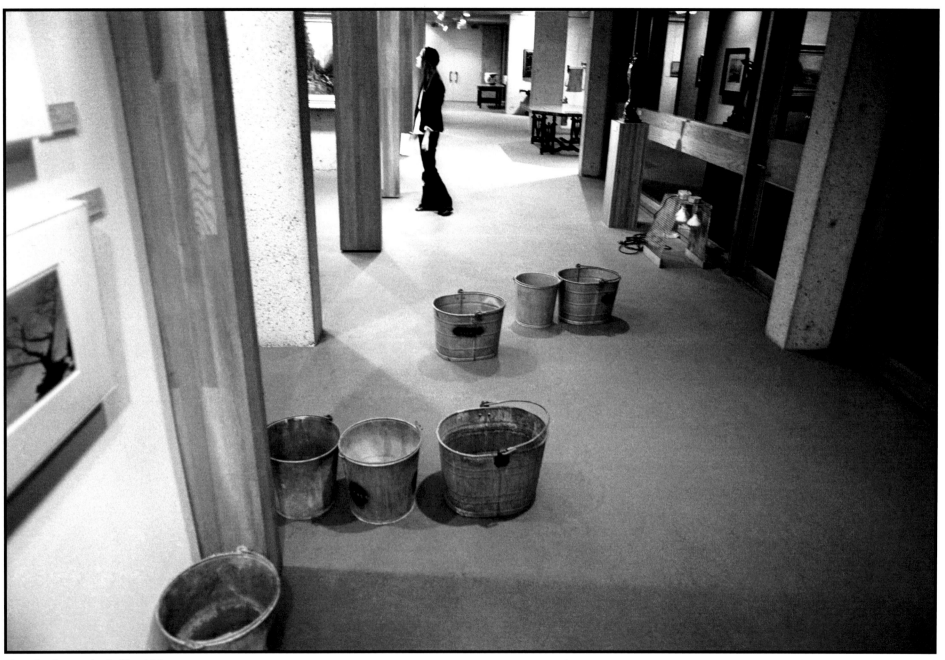

Rain Buckets at the Oakland Museum

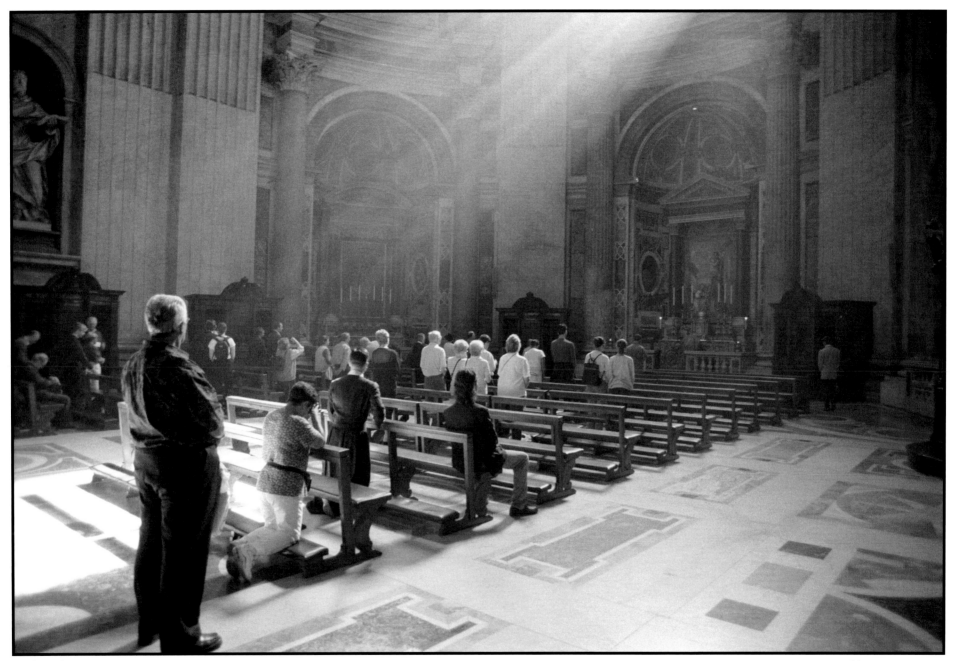

Light and Mass

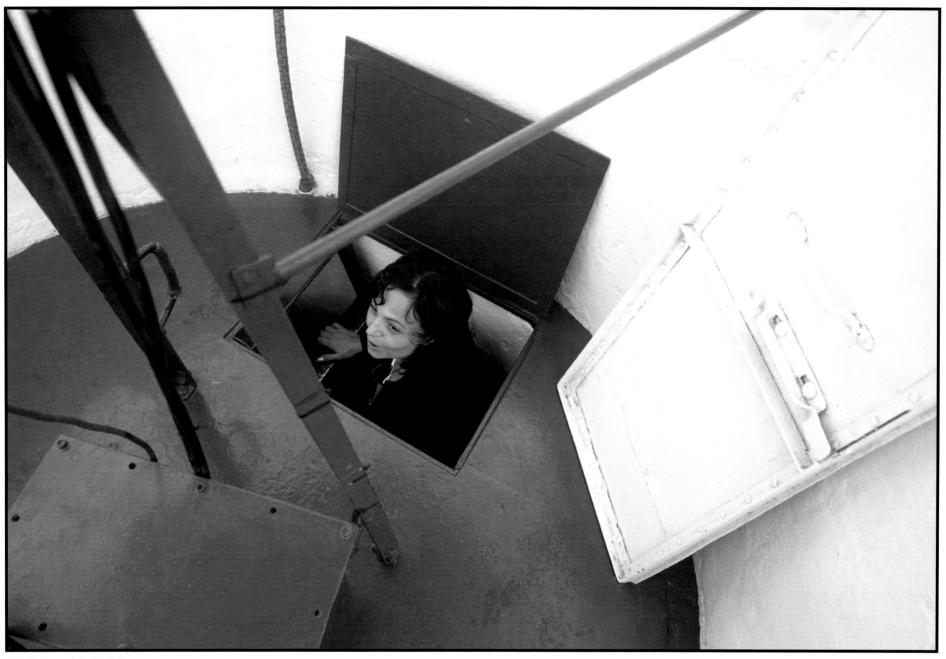

To the Top of the Lighthouse

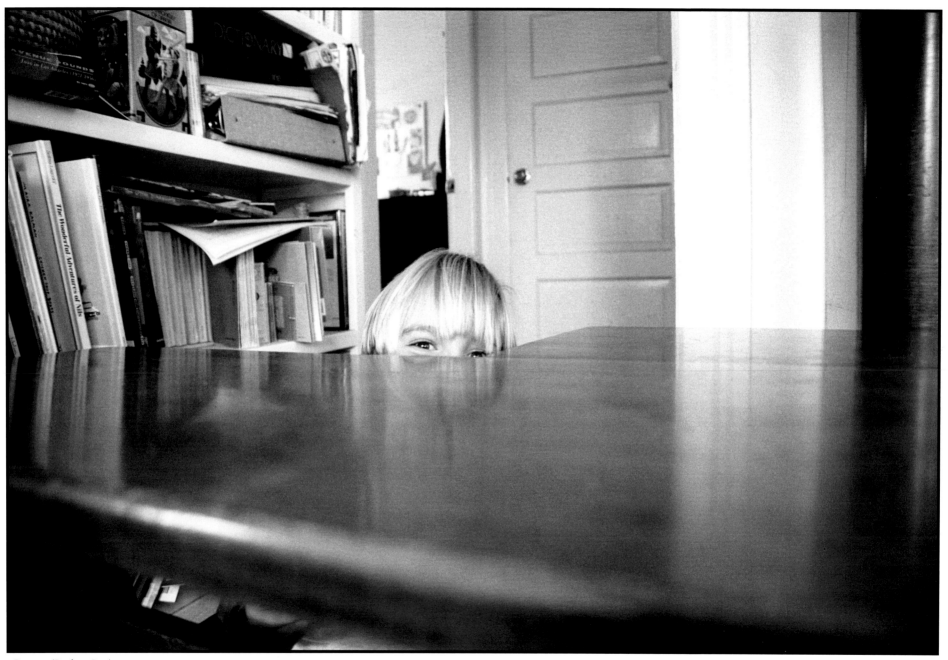

Conner (Peek-a-Boo)

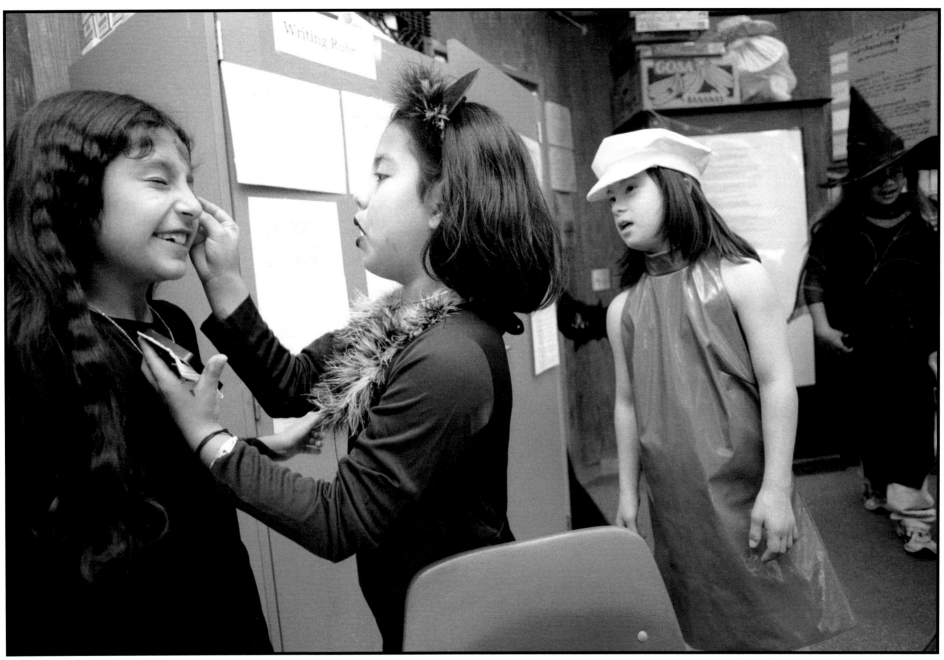

Preparing for the Halloween Parade

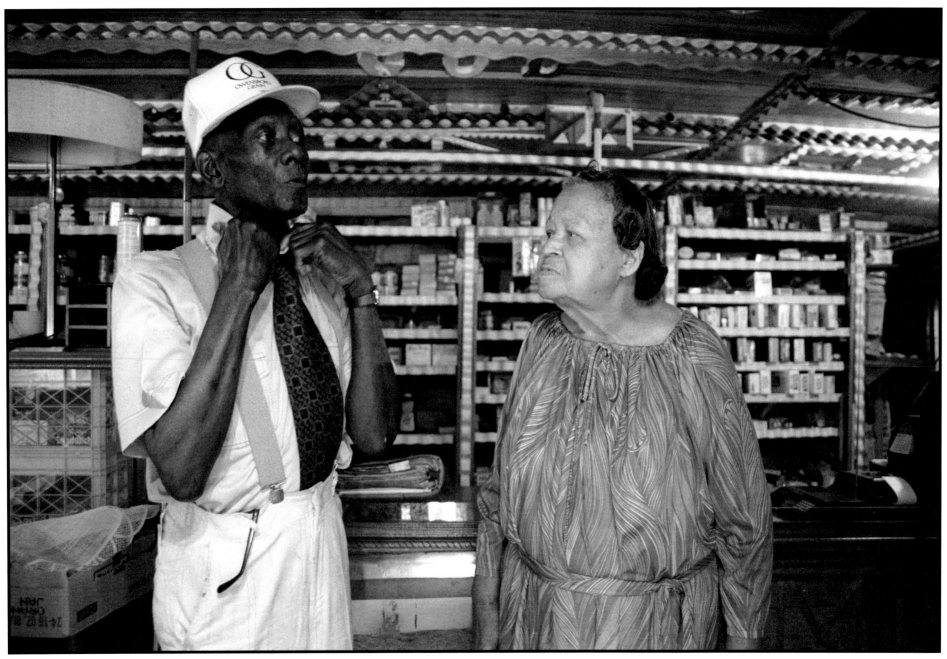

Miss Margaret Advises Rev. Dennis

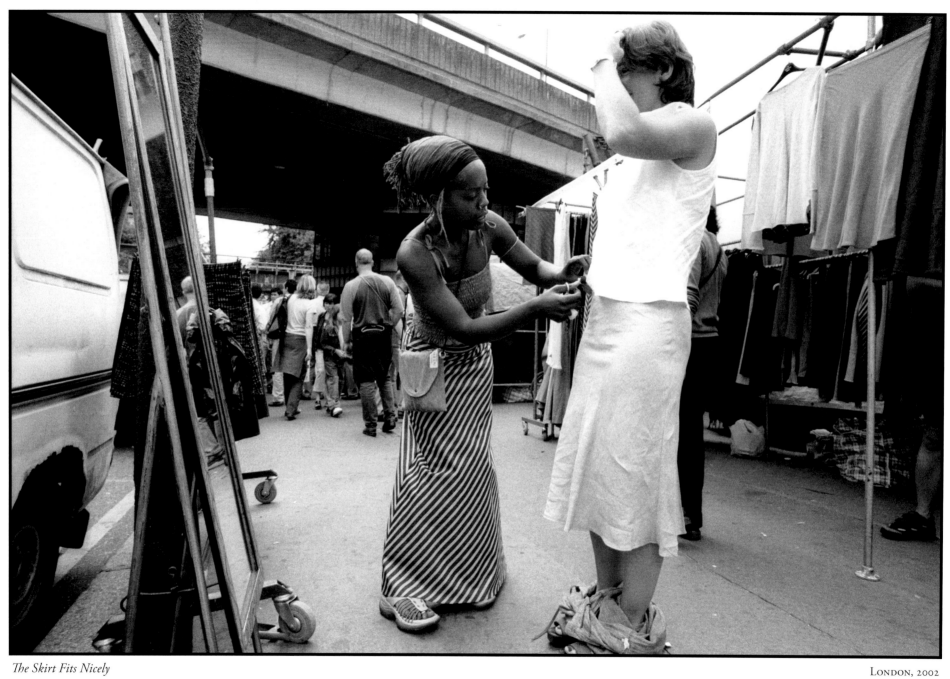

The Skirt Fits Nicely

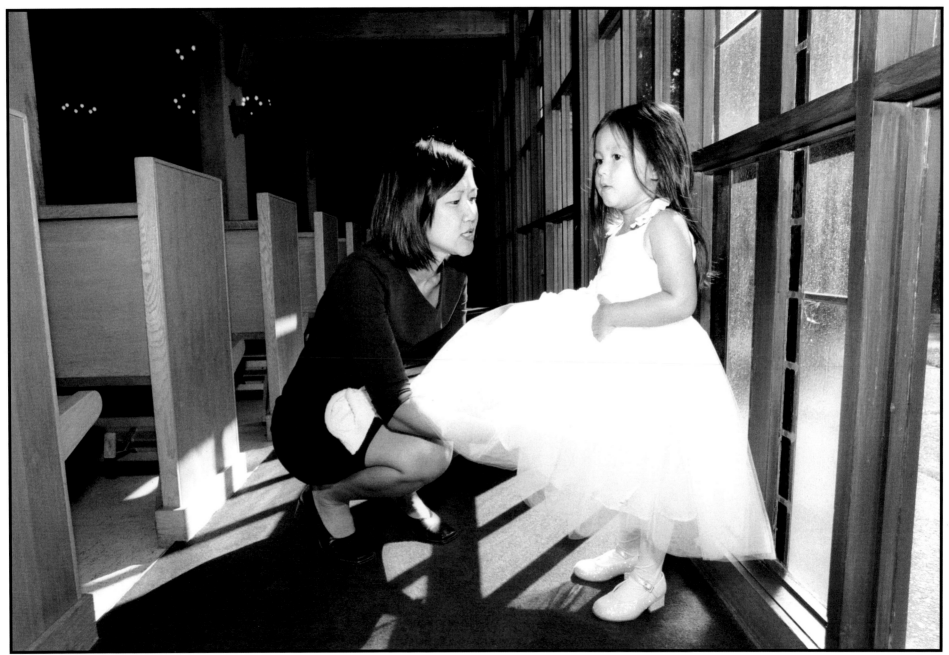

Flower Girl Tended To

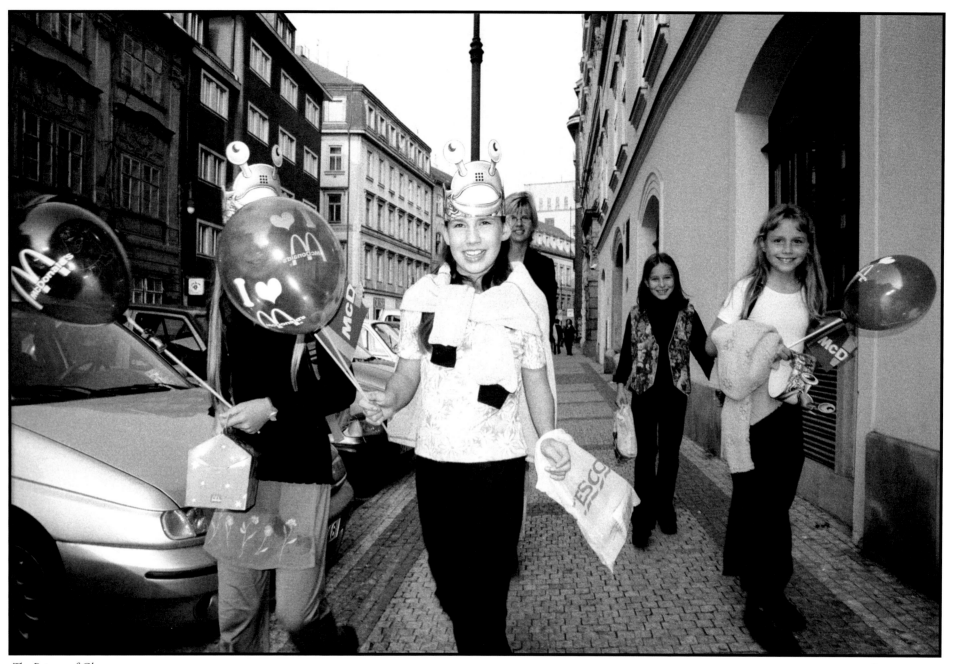

The Return of Glamor

PRAGUE, 2000


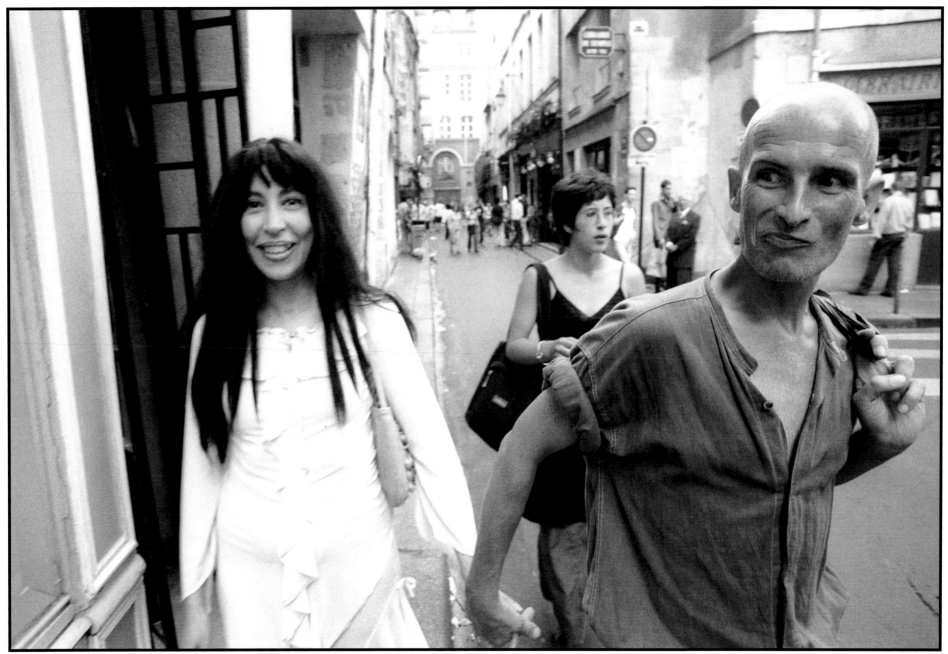

Out, Holding Hands

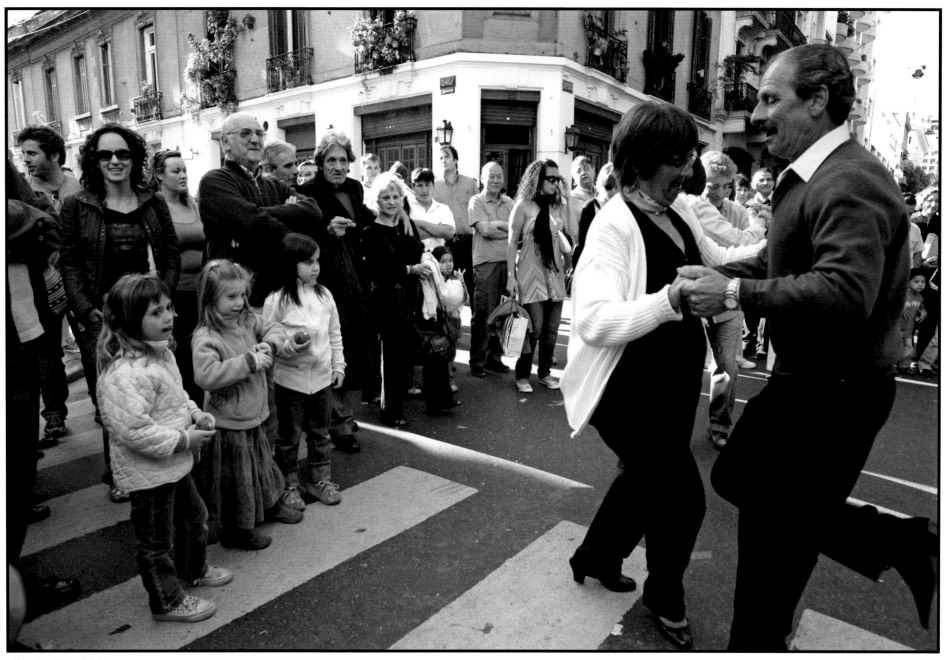

Showing How It's Done

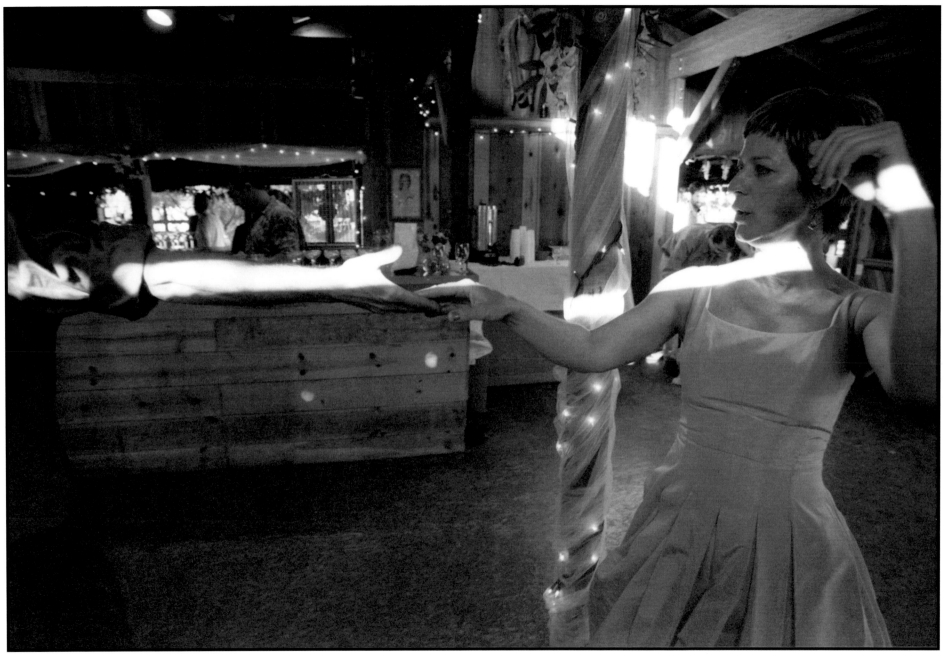

Diane Dancing

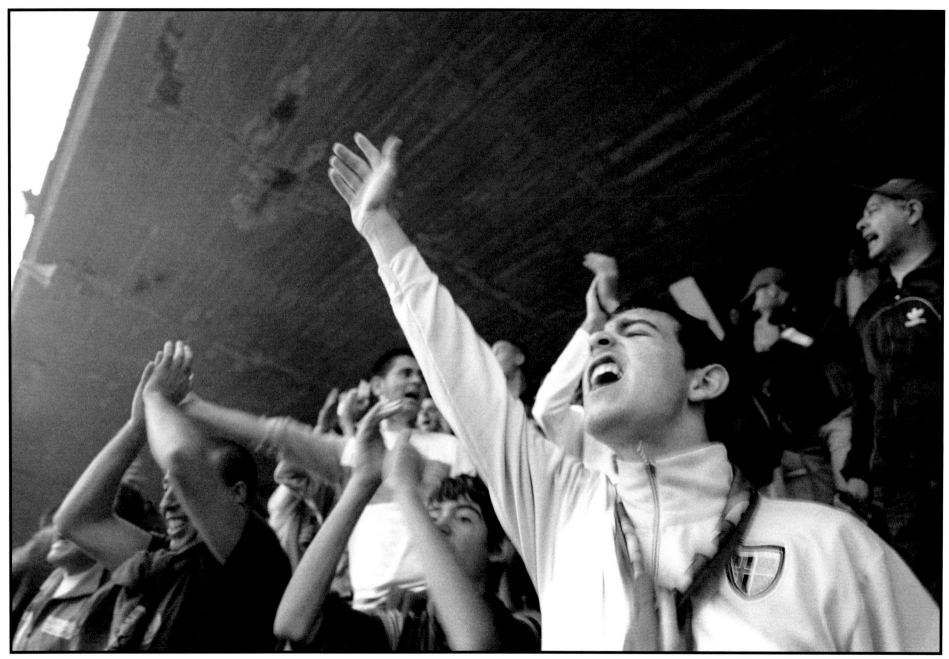

The Fan

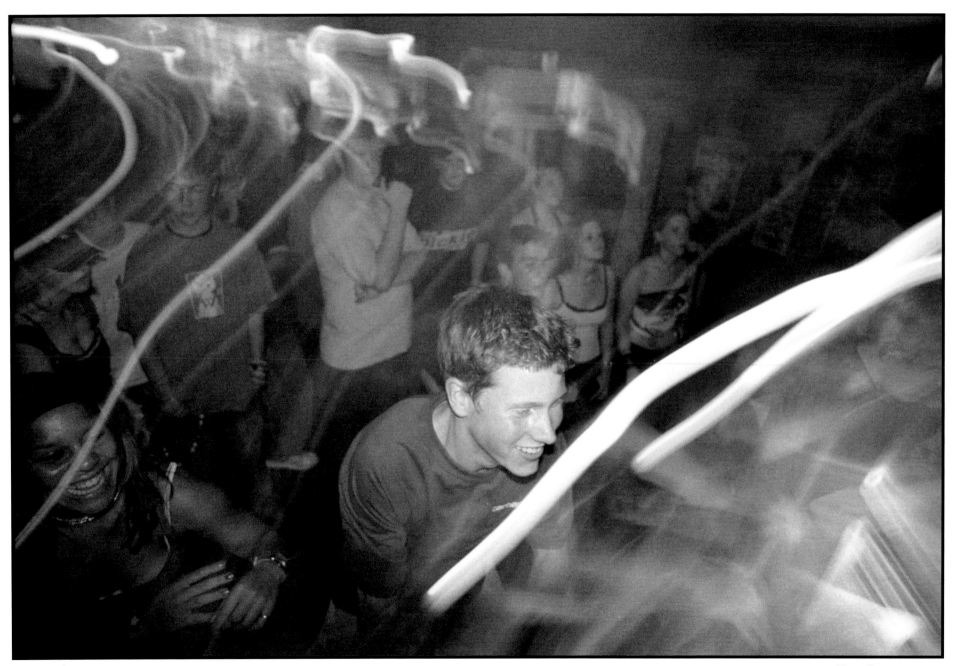

Teen Mosh

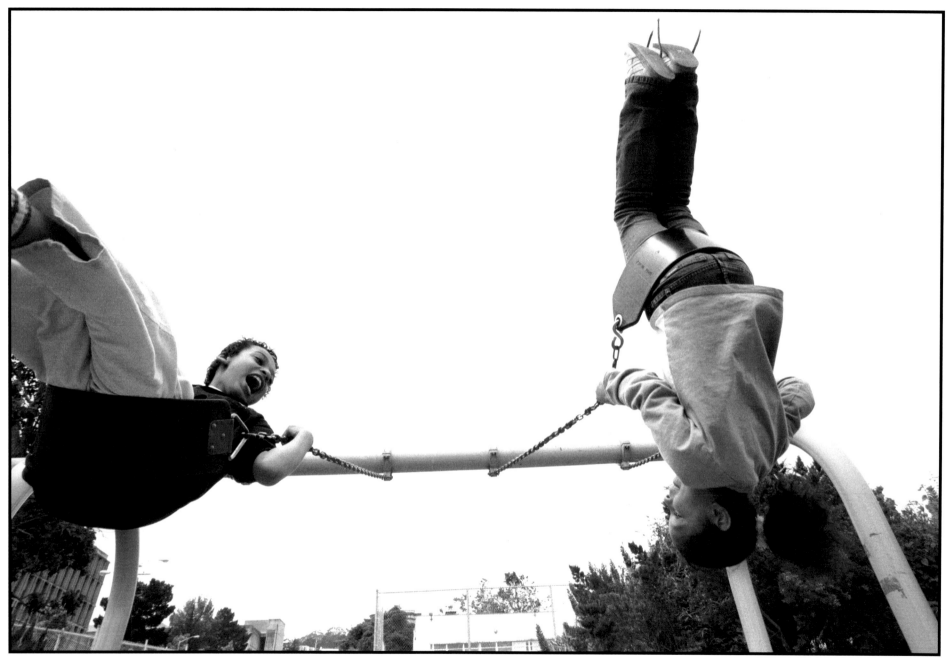

Swingin'

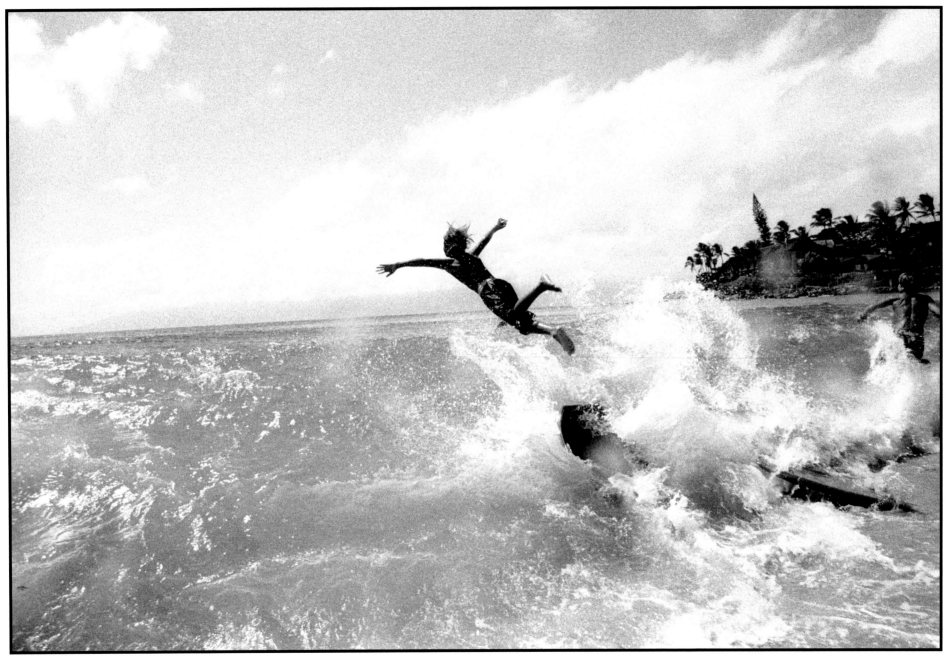

Taking Flight in Maui

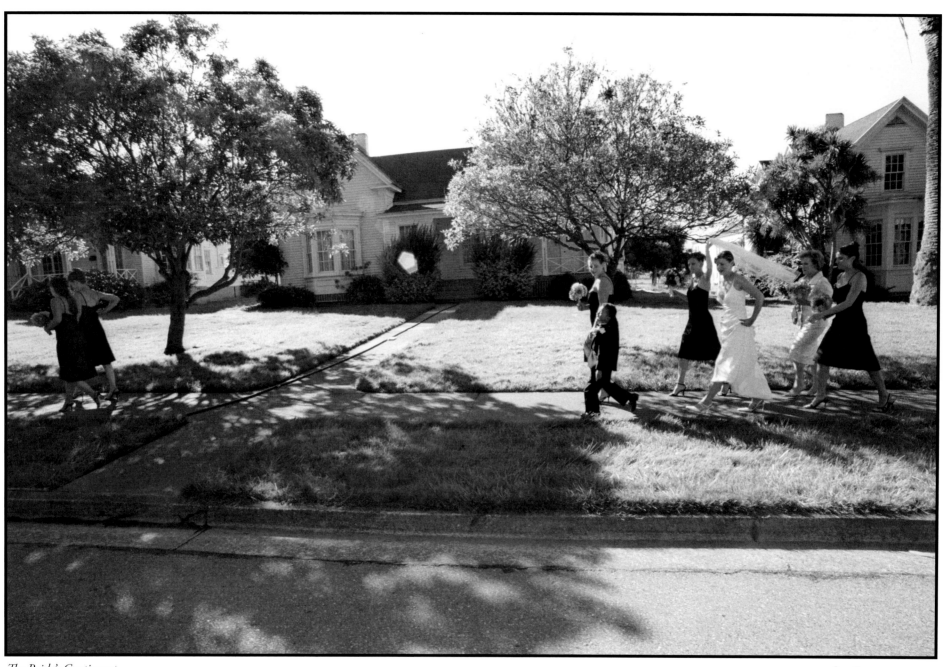

The Bride's Contingent

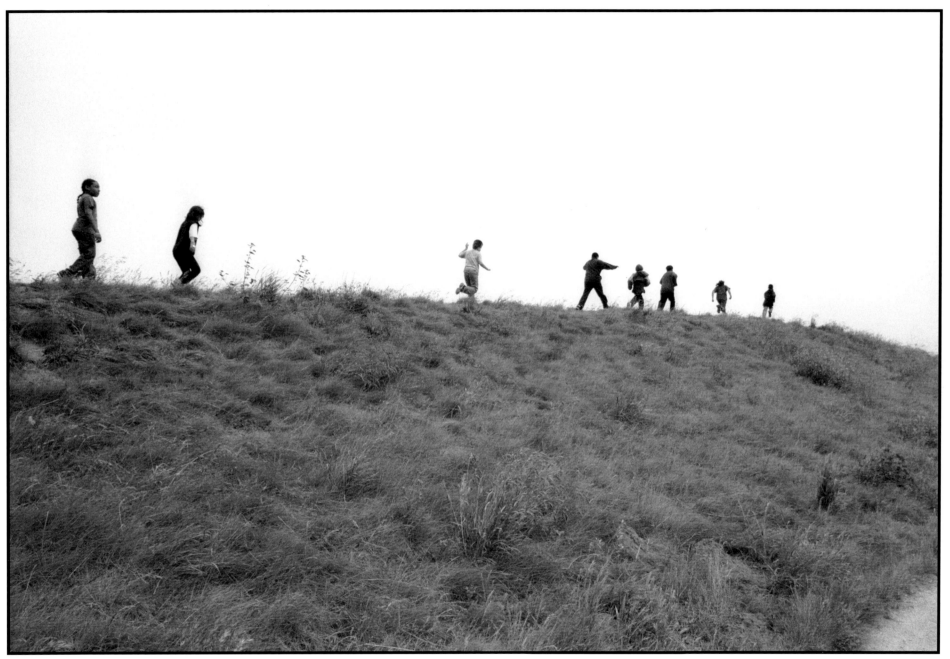

Running the Berm

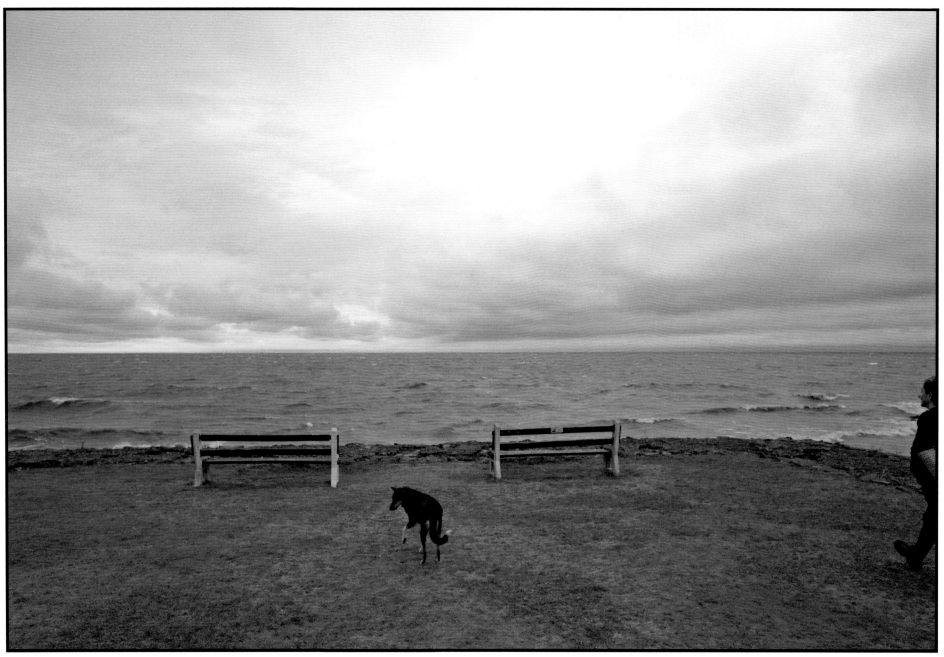

A Bench for Each

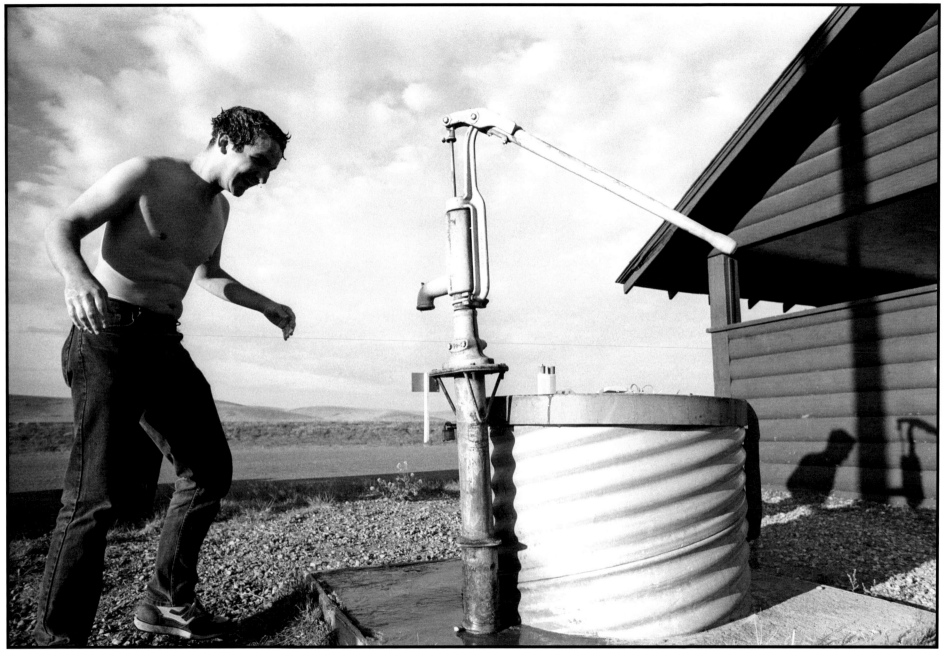

Morning Roadside Washup

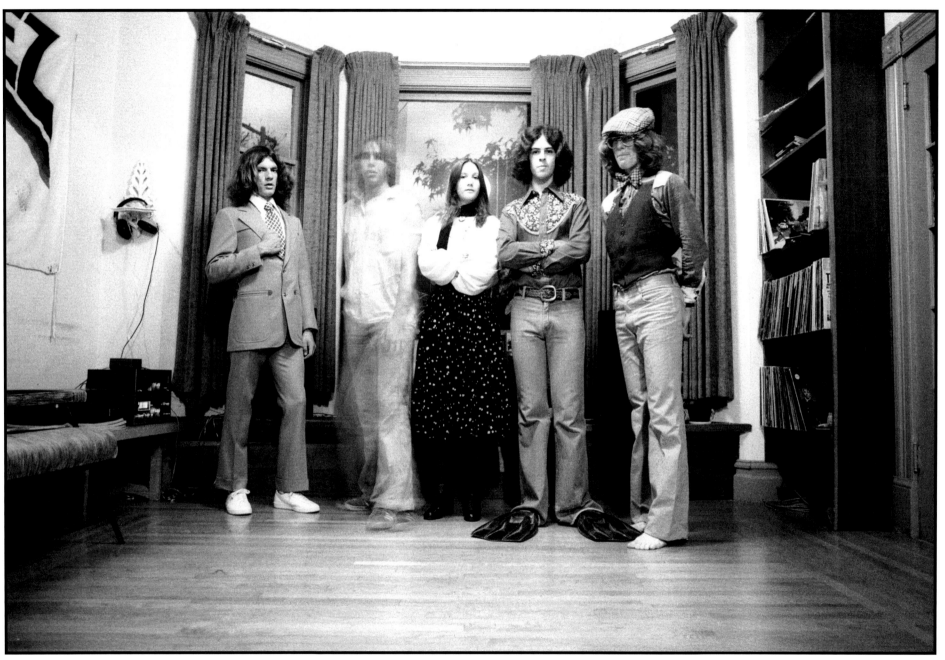

House Portrait

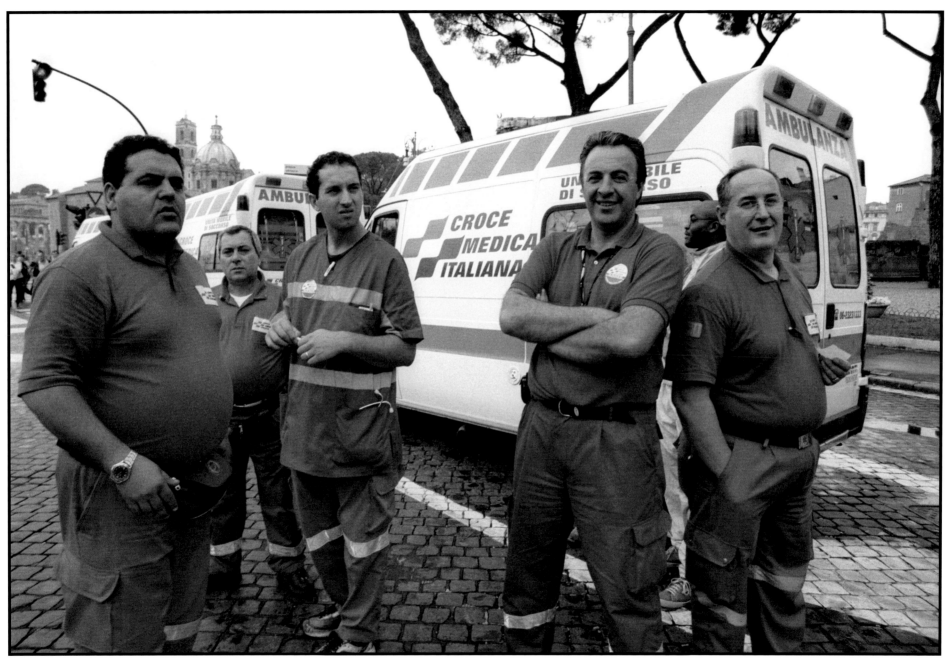

In Case of Emergency

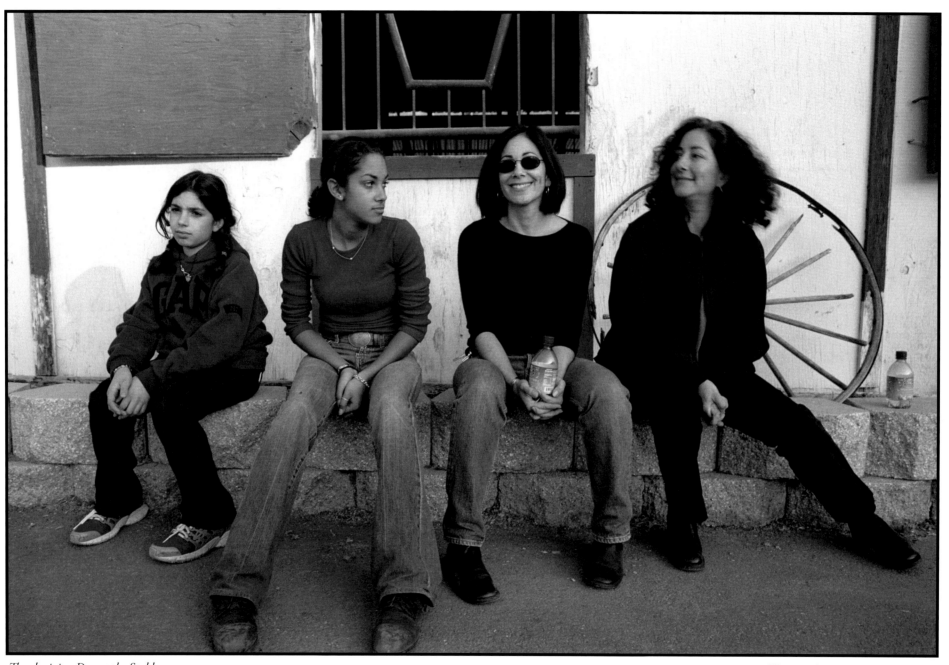

Thanksgiving Day at the Stables

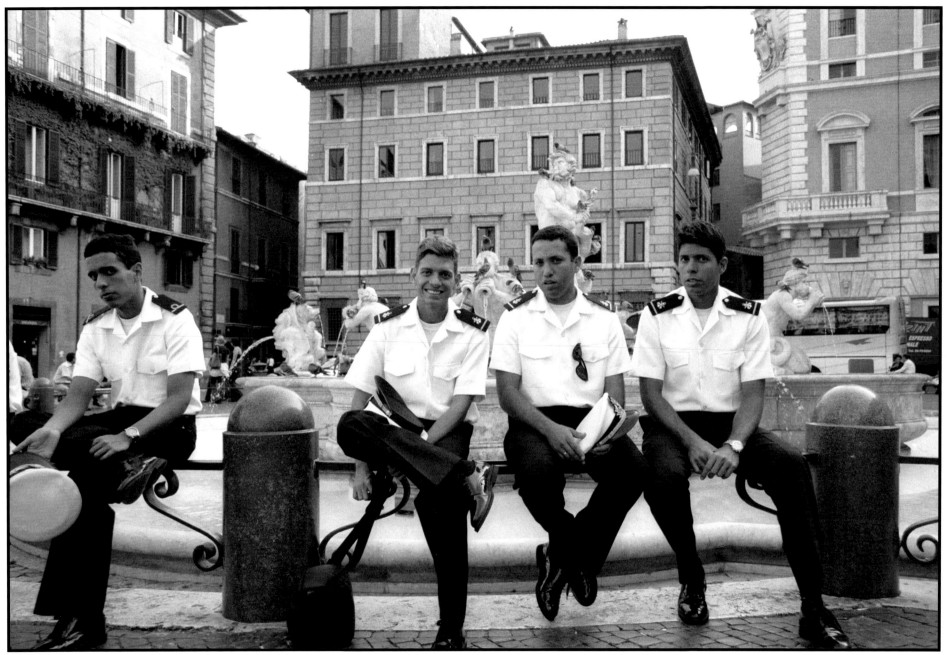

Brazilian Officers in Rome

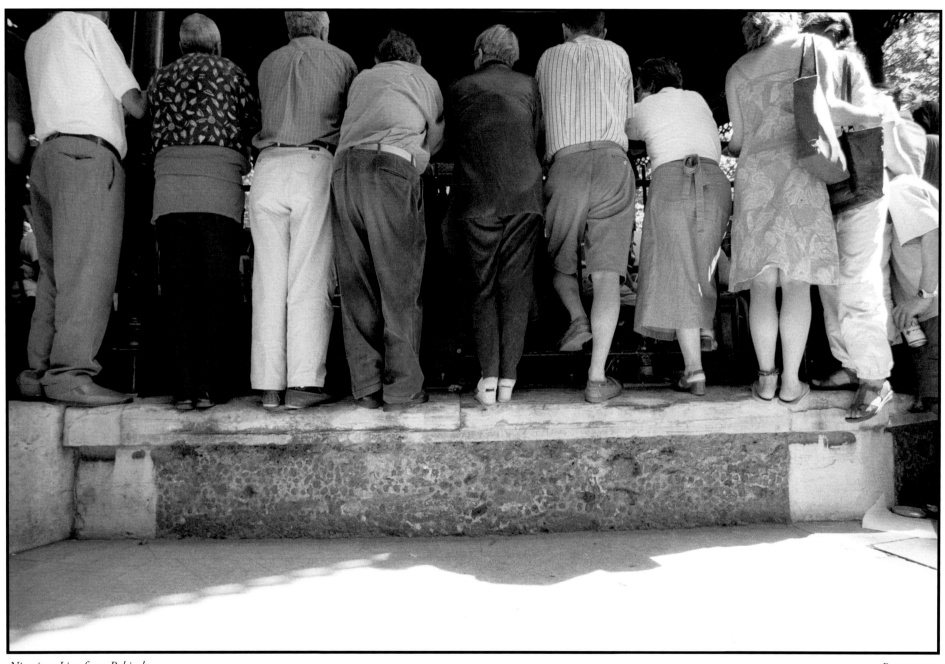

Nine in a Line from Behind

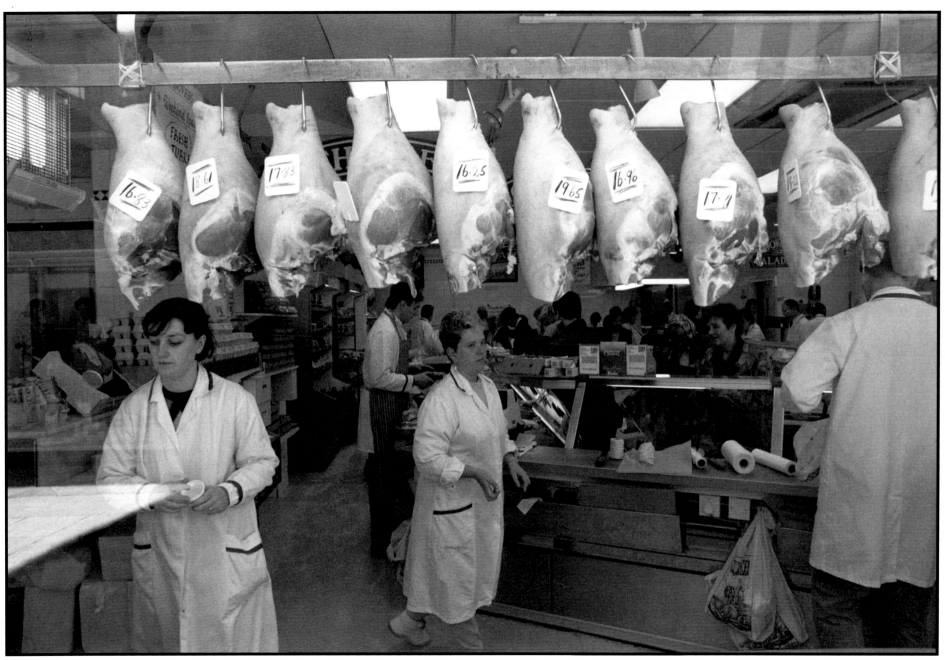

Nine Hams Hanging

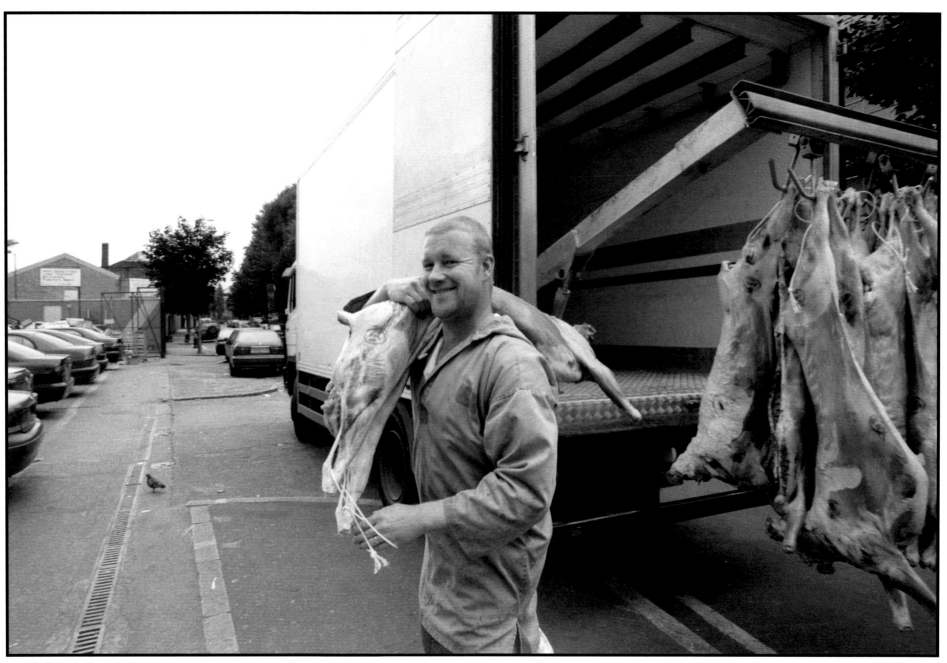

Lamb, Straight from the Lorry

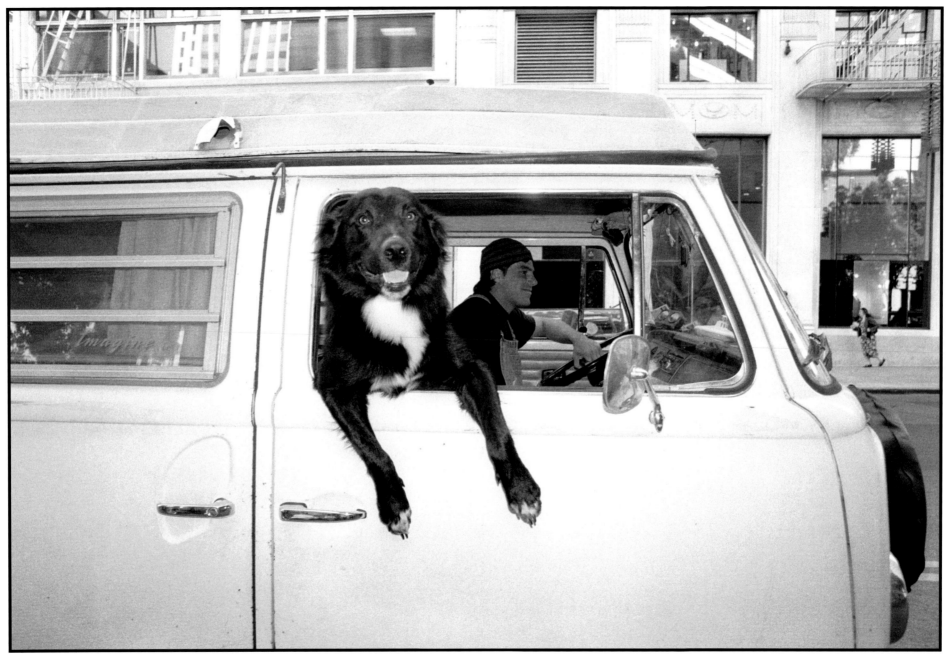

Dog as Co-Pilot

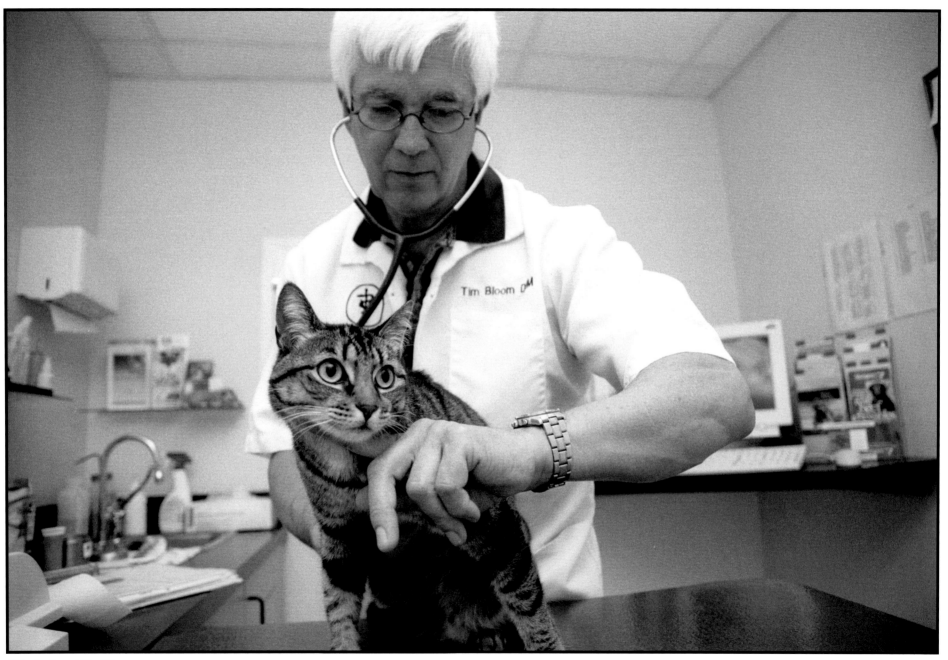

Elizabeth and Dr. Bloom

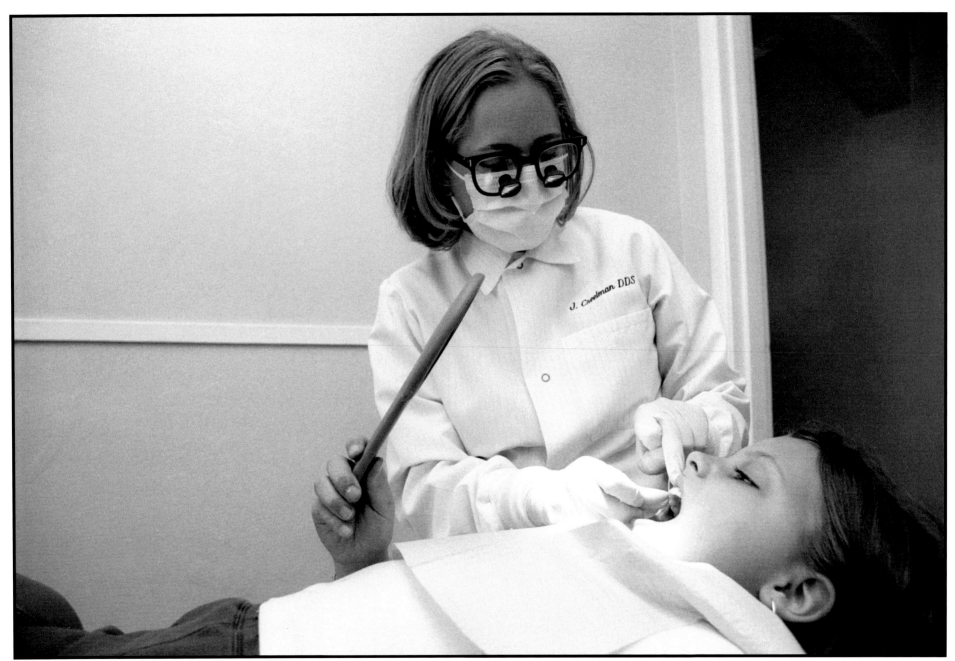

Dr. Creelman's Flossing Lesson

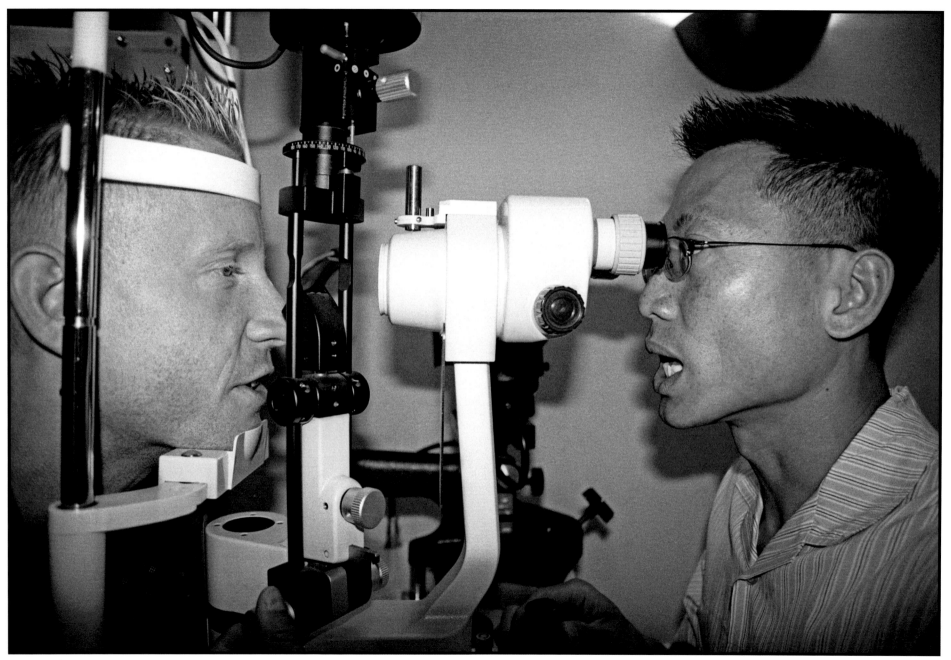

Eye Exam

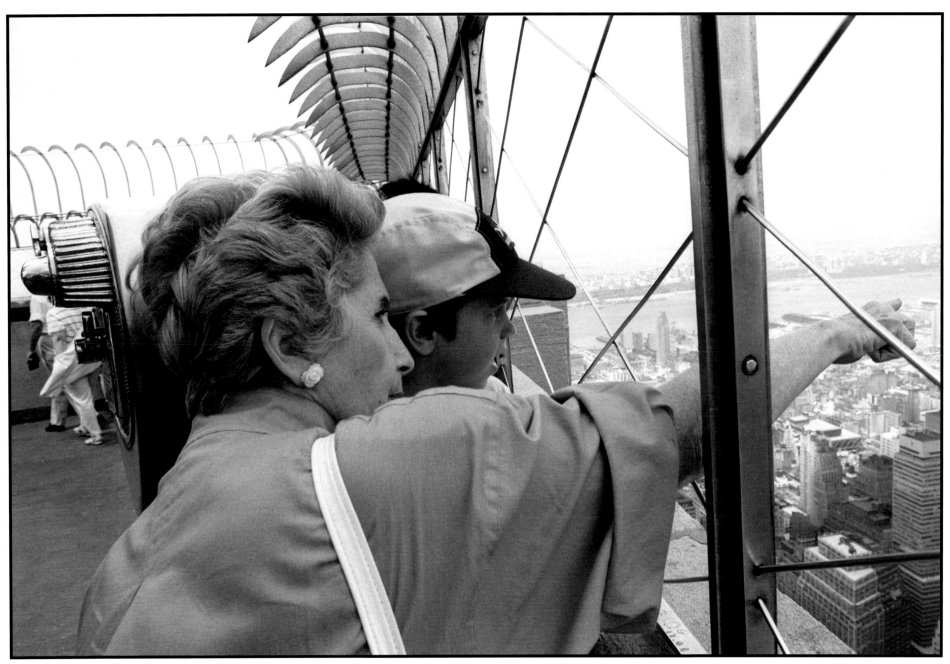

Showing Grandson Around Manhattan

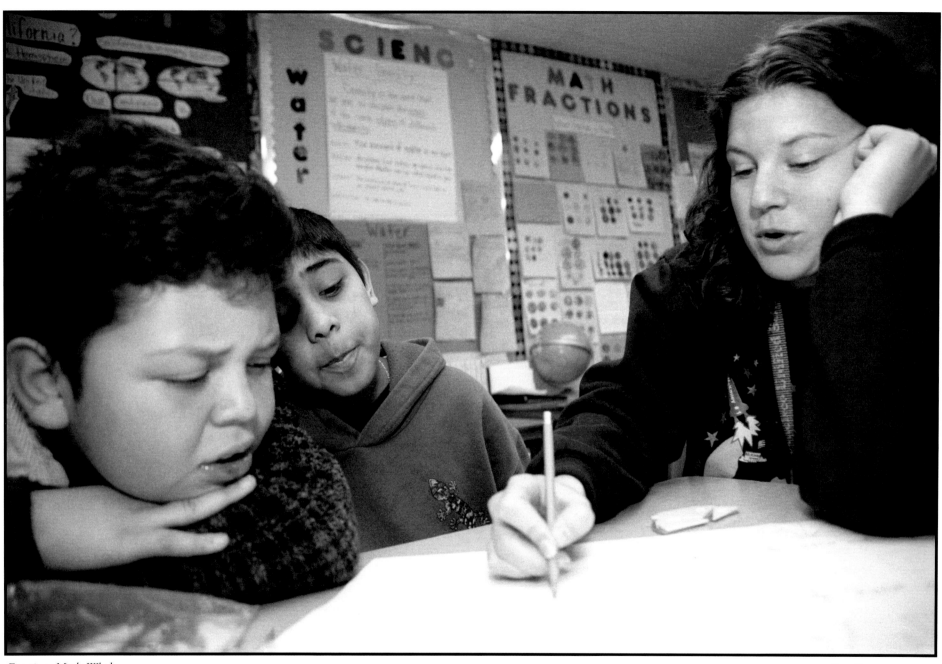

Fractions Made Whole

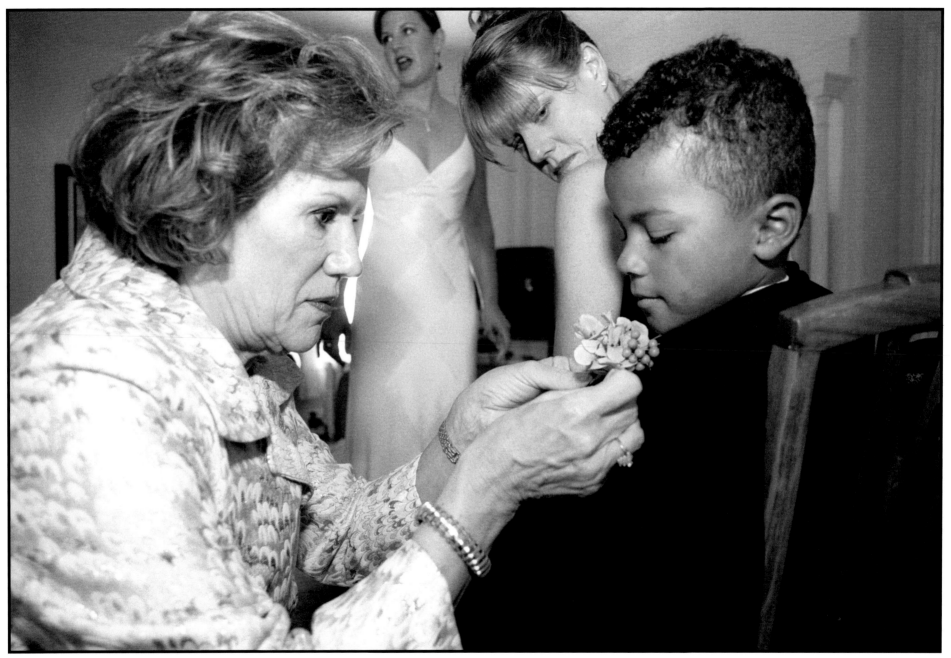

His First Boutonniere

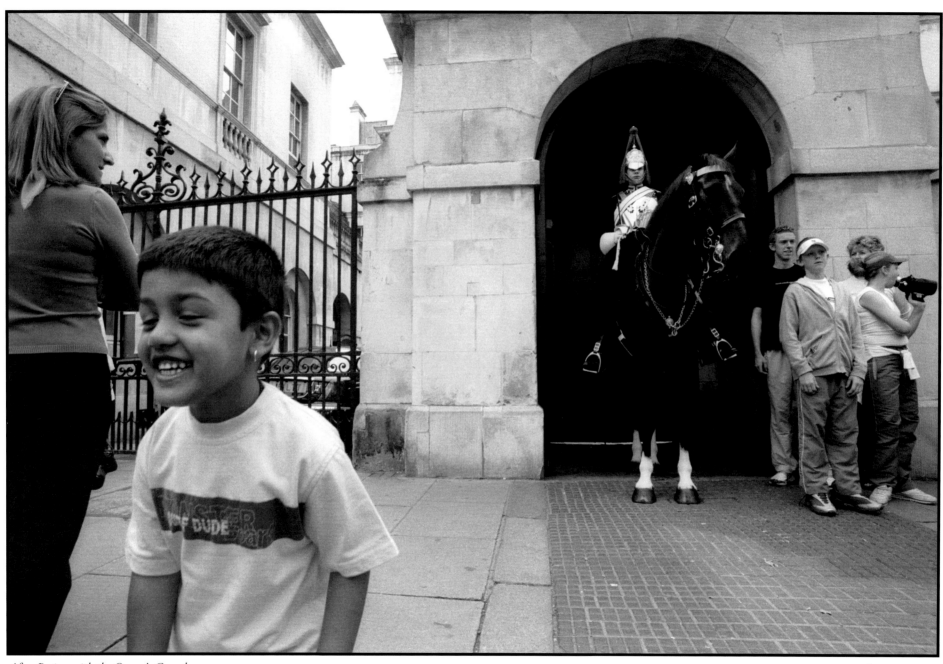

After Posing with the Queen's Guard

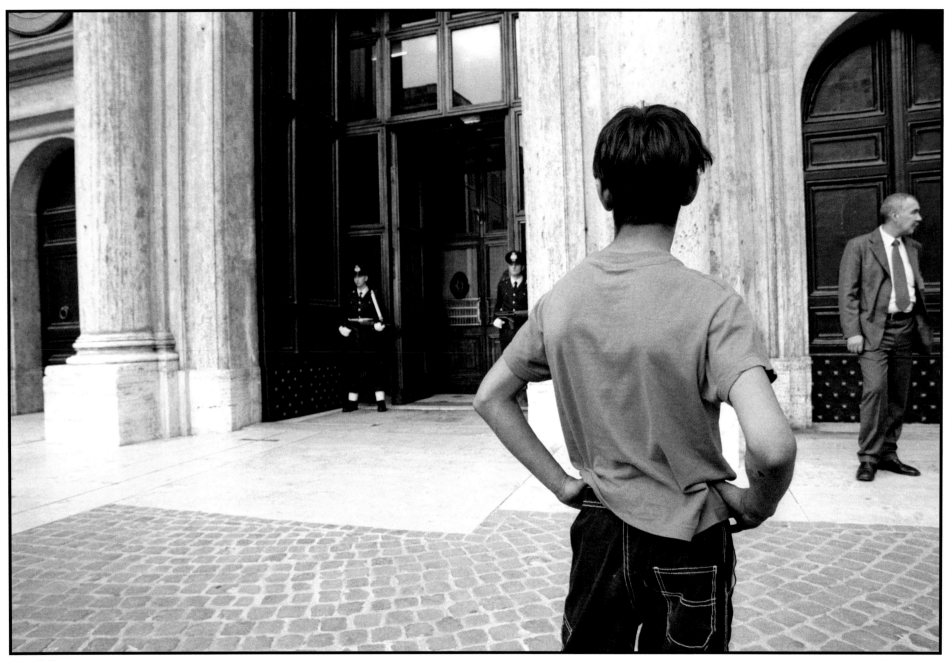

Standoff

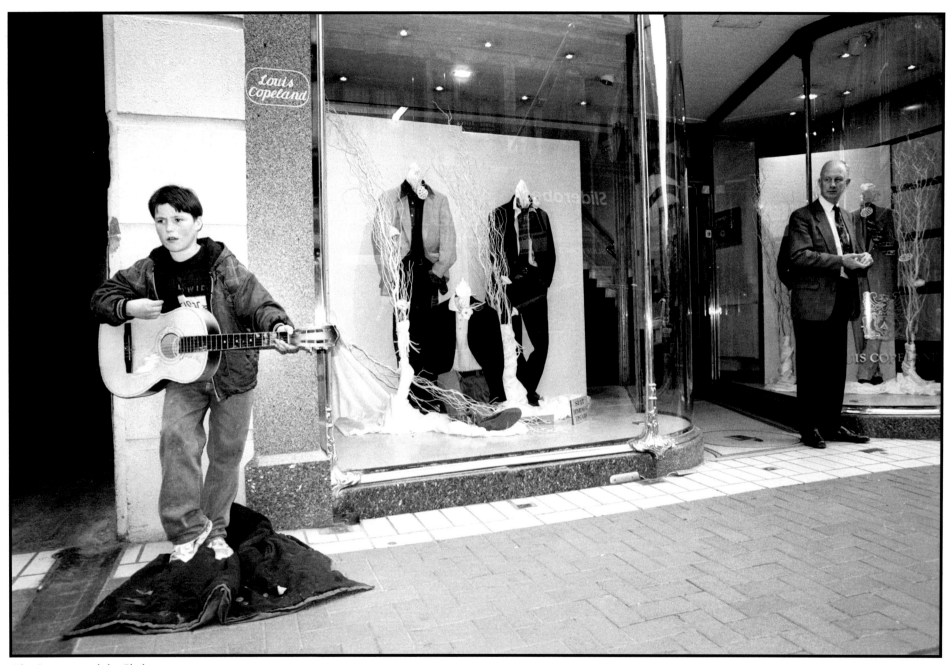

The Guitarist and the Clothier

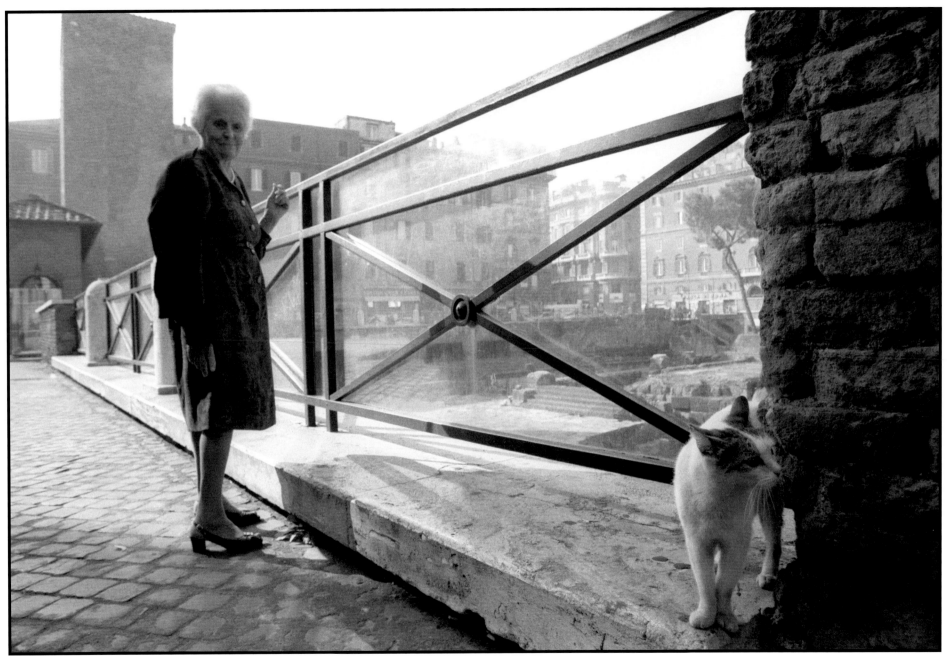

Visiting Her Cat

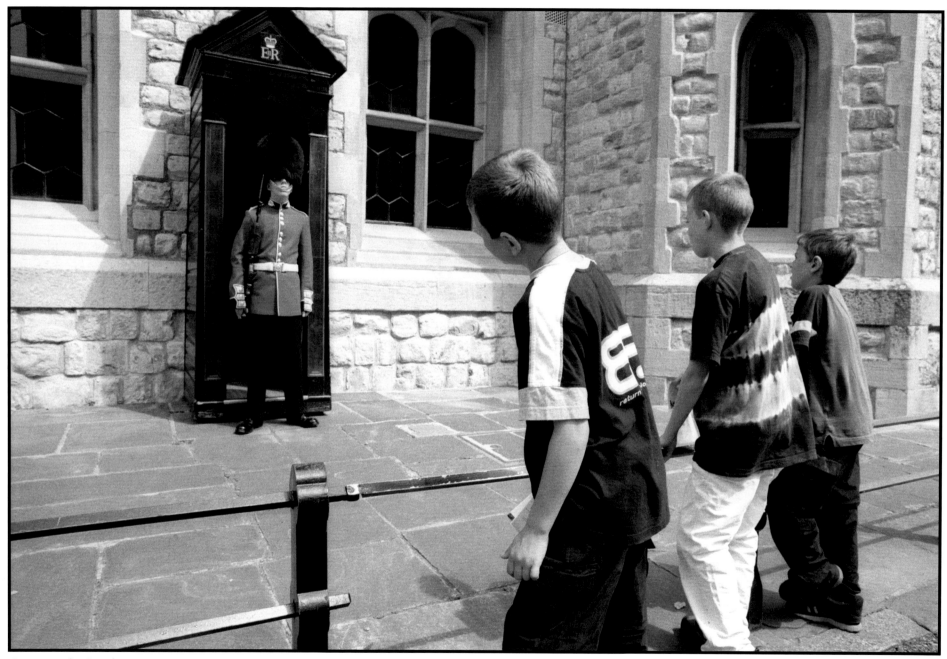

Reviewing the Guard

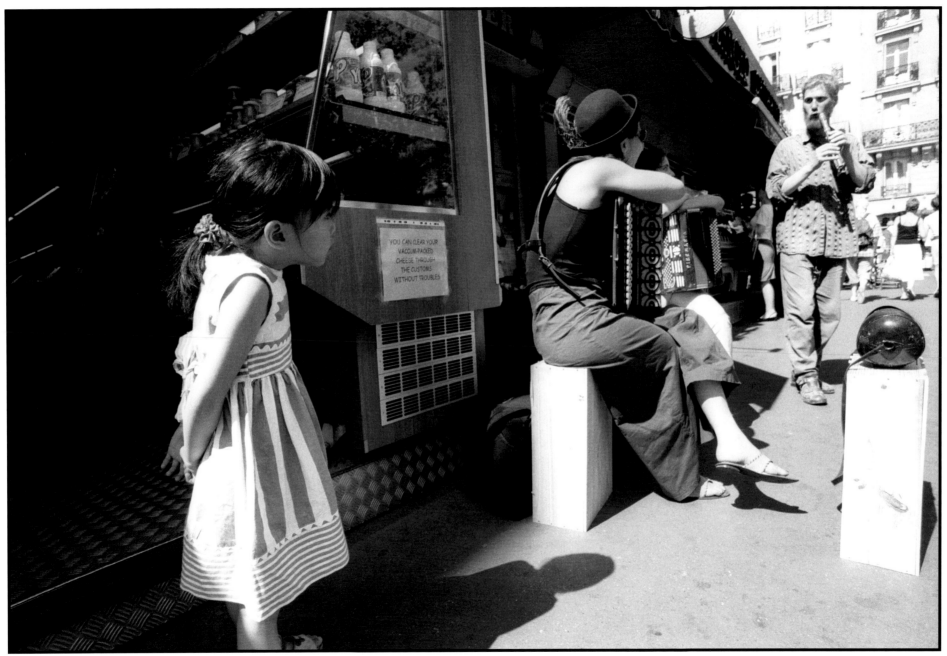

Small Audience

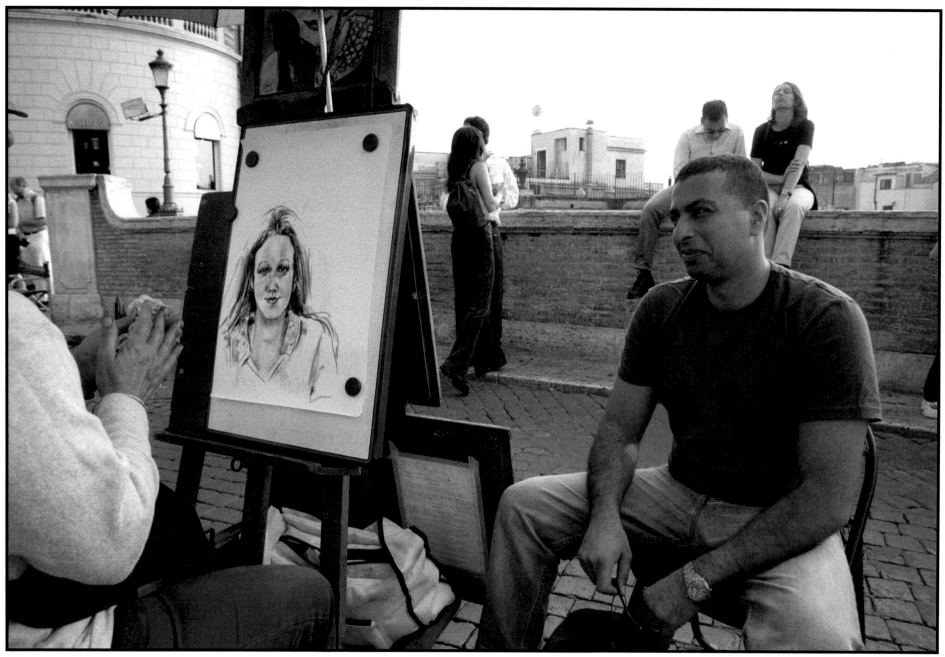

Artistic License

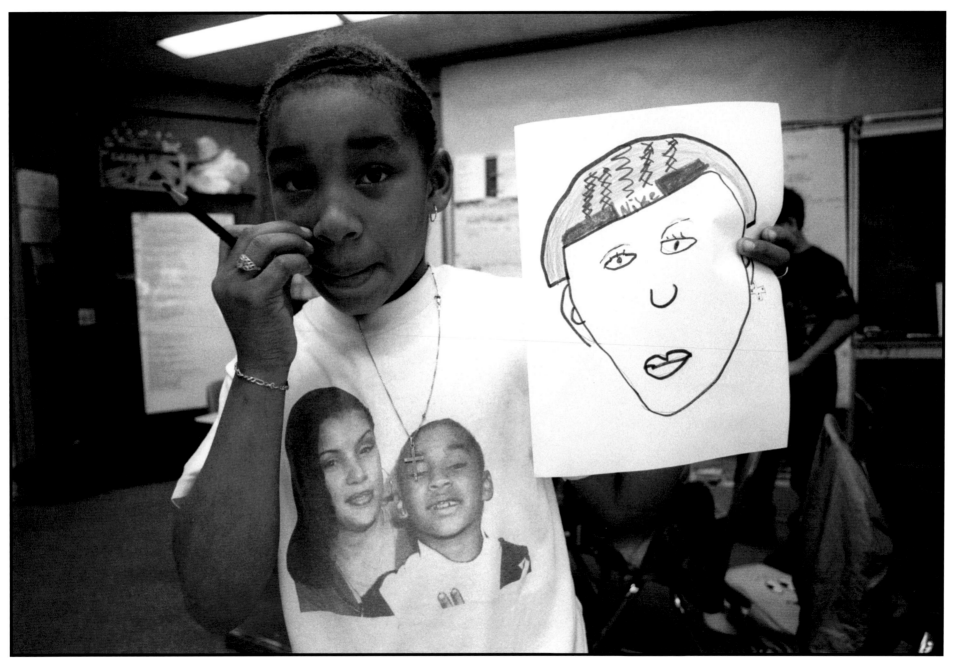

Portraits of Shawnee

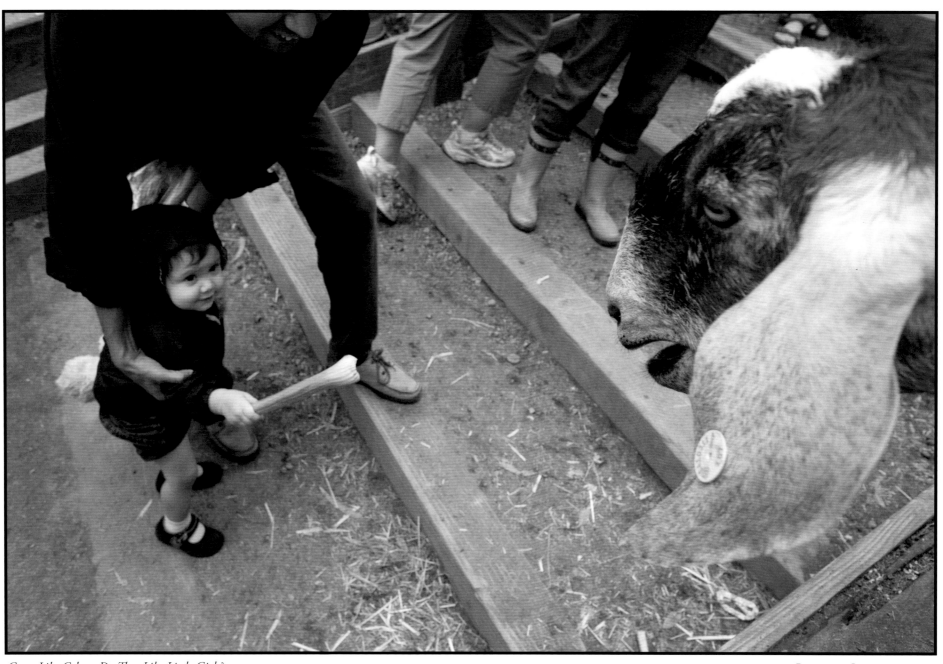

Goats Like Celery. Do They Like Little Girls?

BERKELEY, CALIFORNIA, 2007

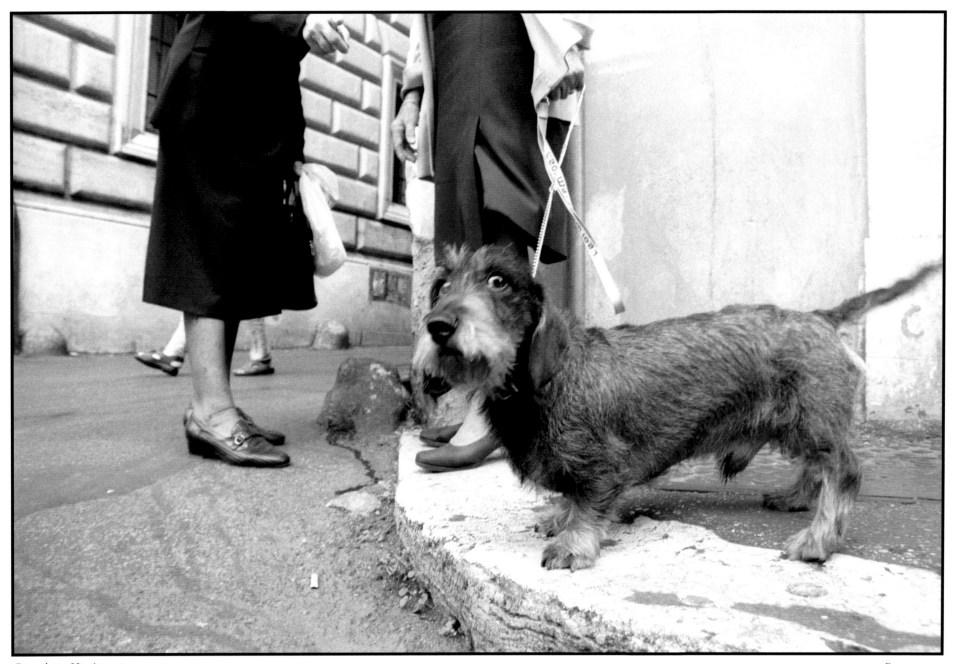

Brought to His Attention

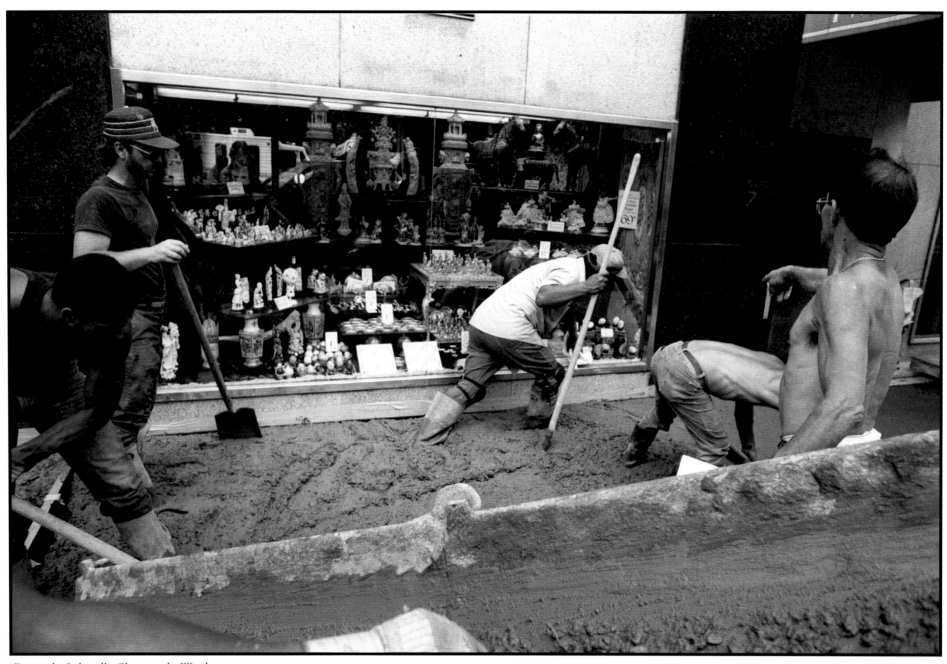

Fixing the Sidewalk, Cleaning the Window

New York City, 1987

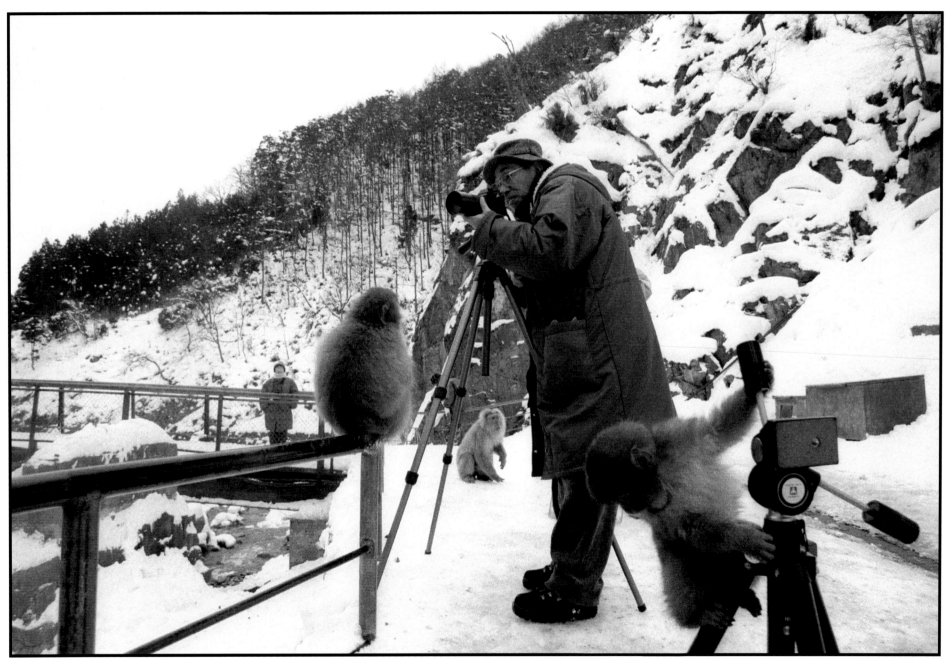

Contending with Snow Monkeys

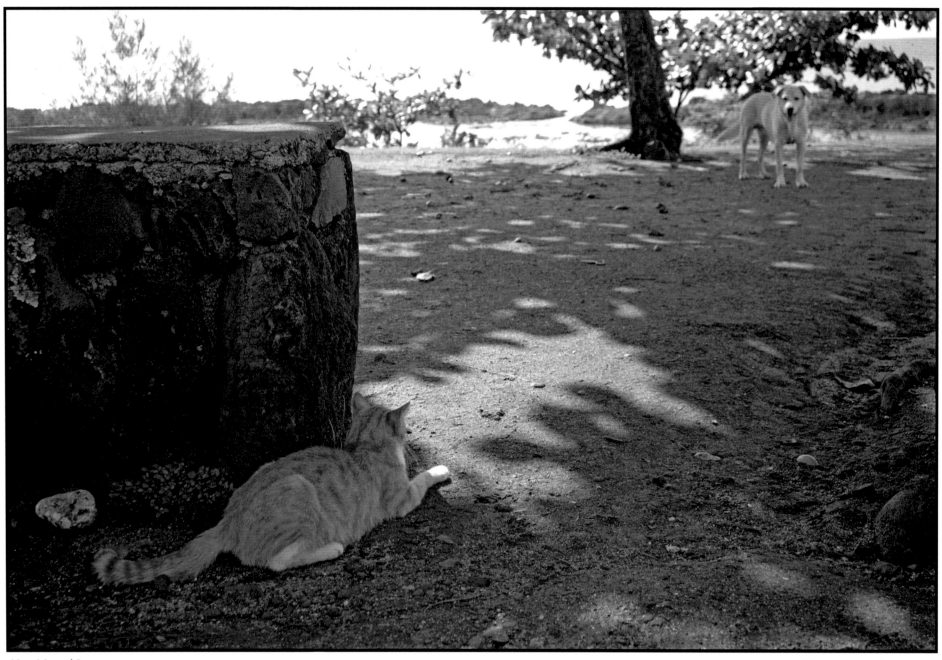

Non-Mutual Interest

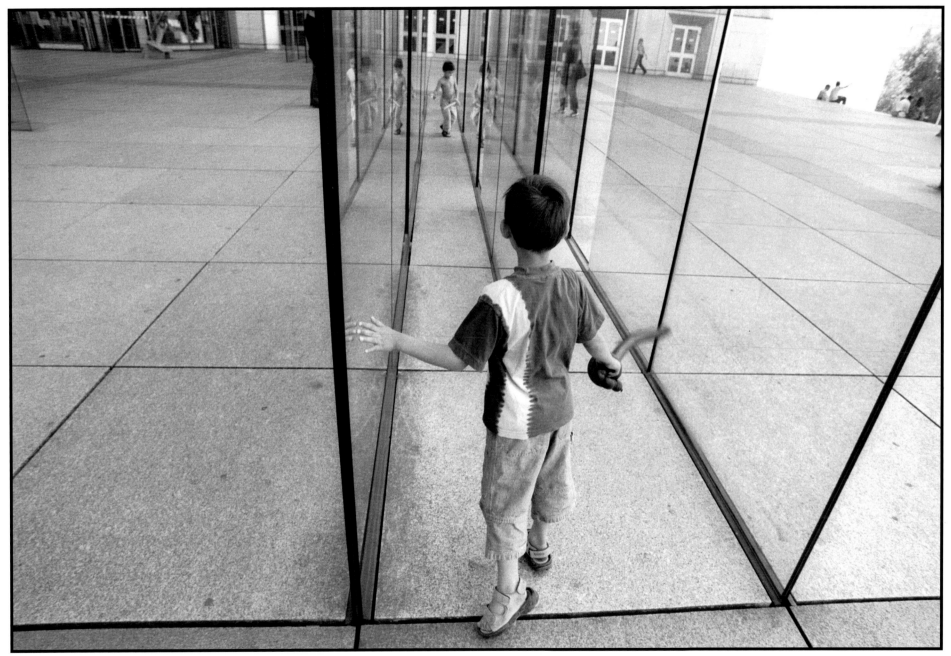

Swordplay at La Defense

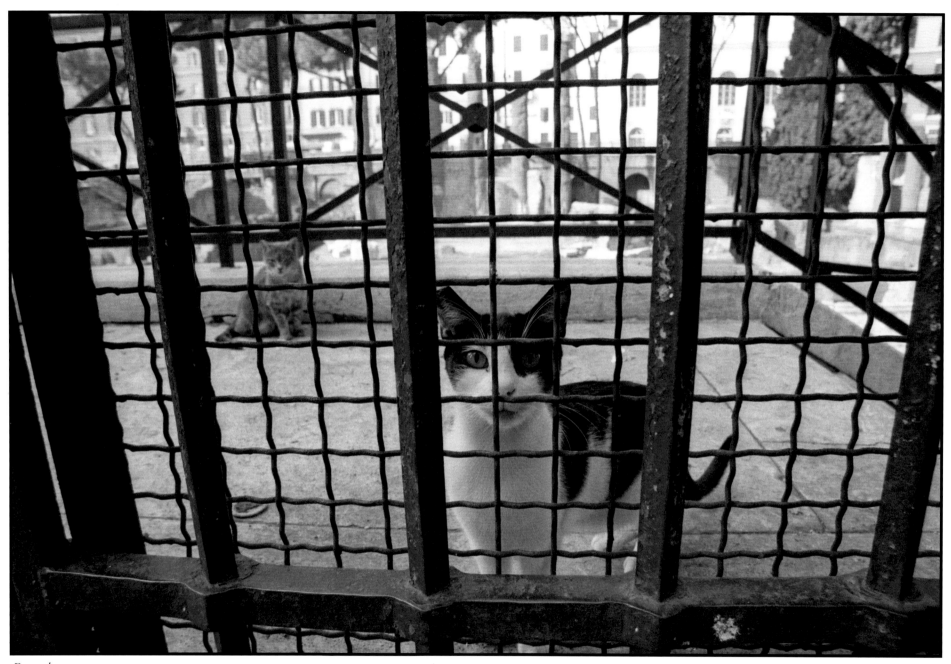

Framed

ROME, 2001

60

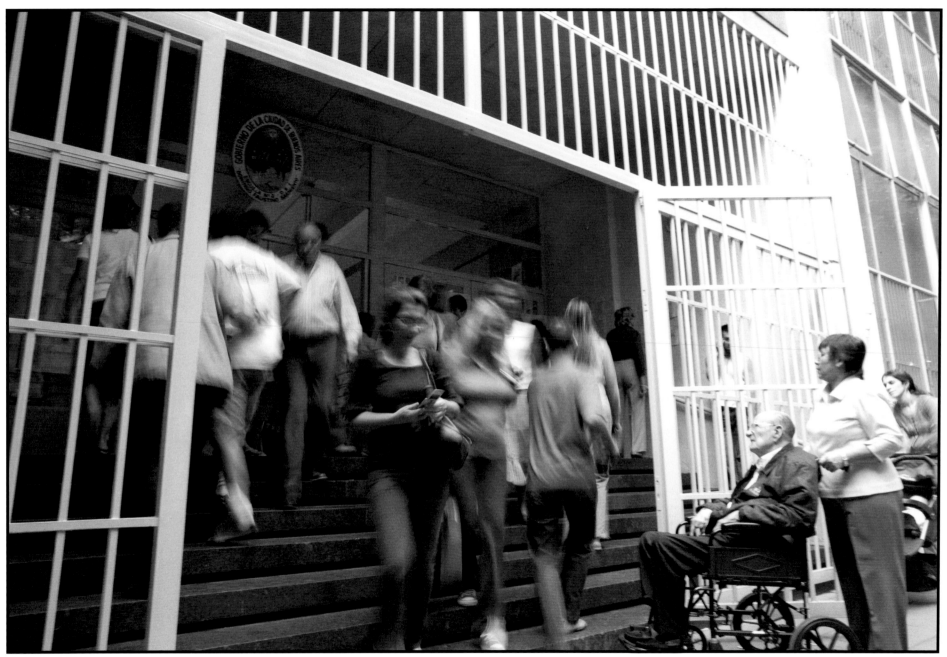

Access to the Polls

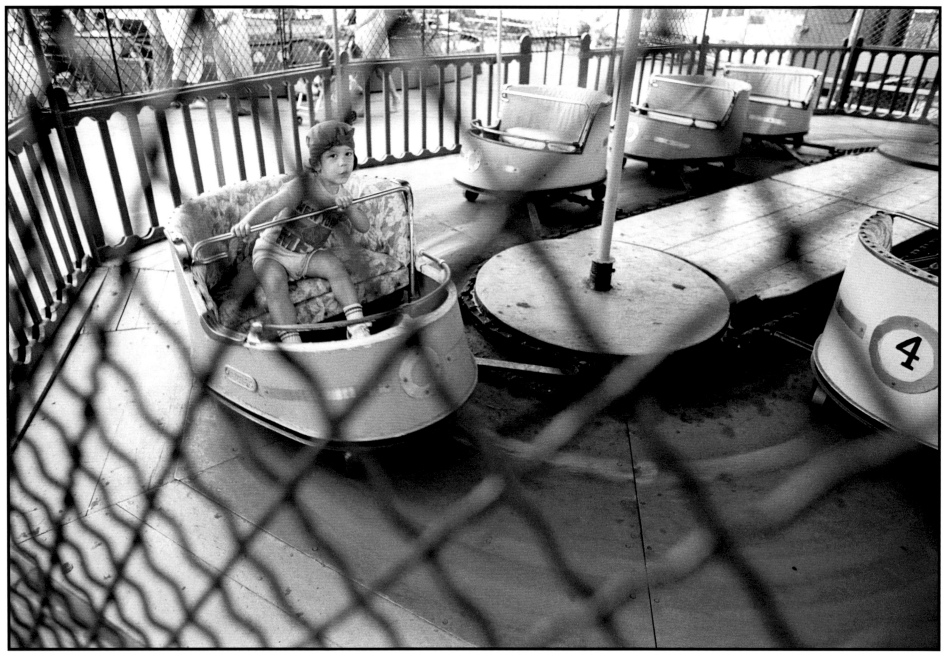

Daredevil

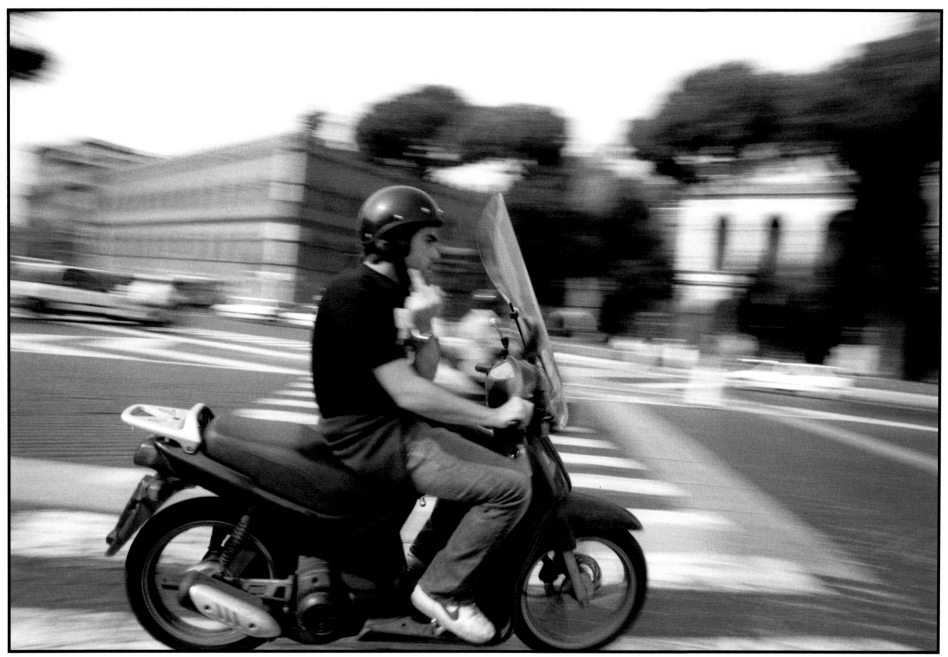

Scooters Are Number One

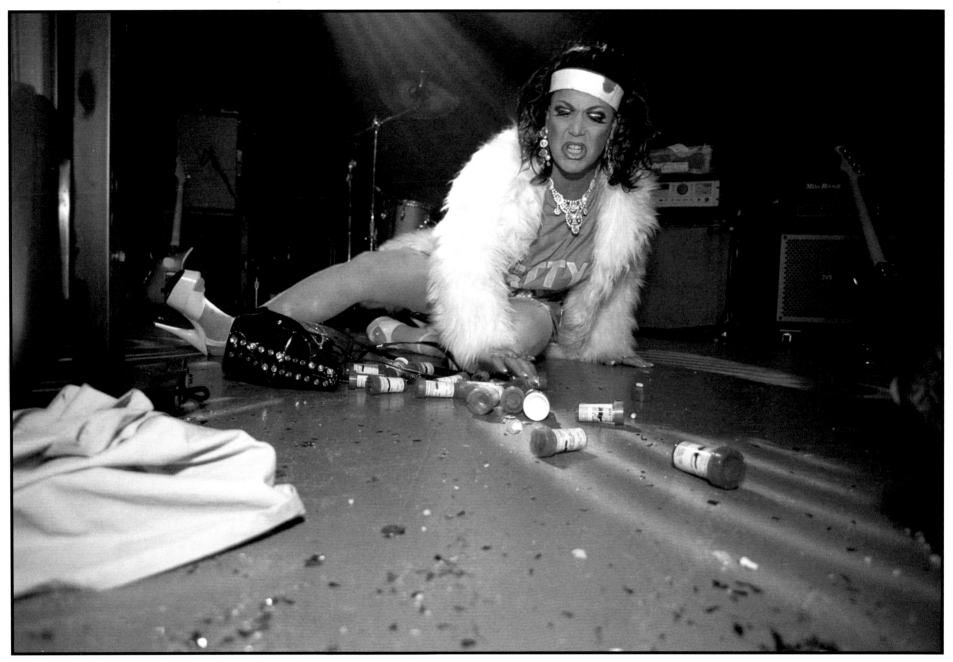

Spilled Pills

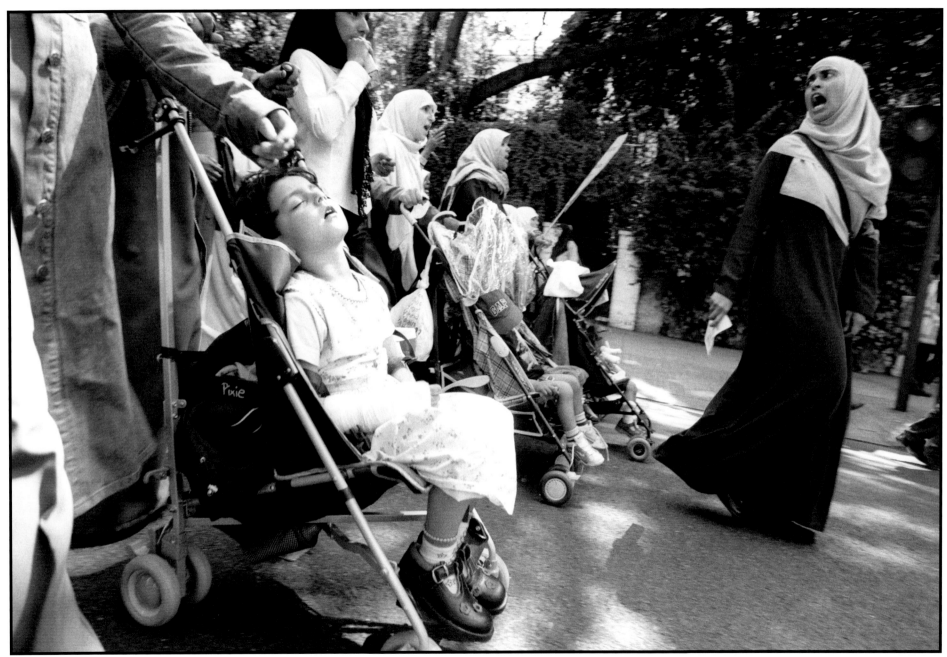

Impassioned Leader

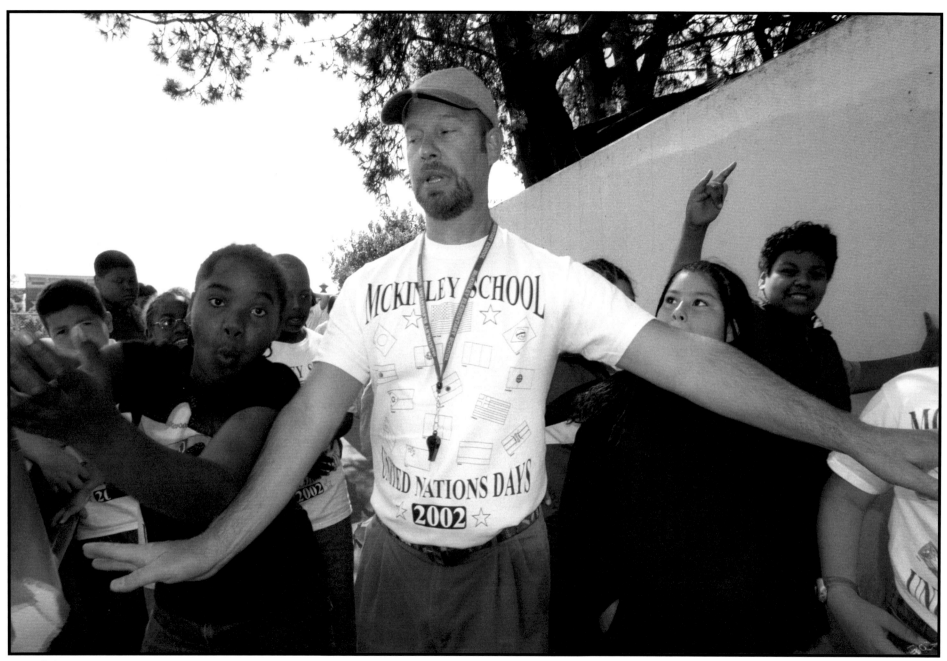

Disorderly Procession

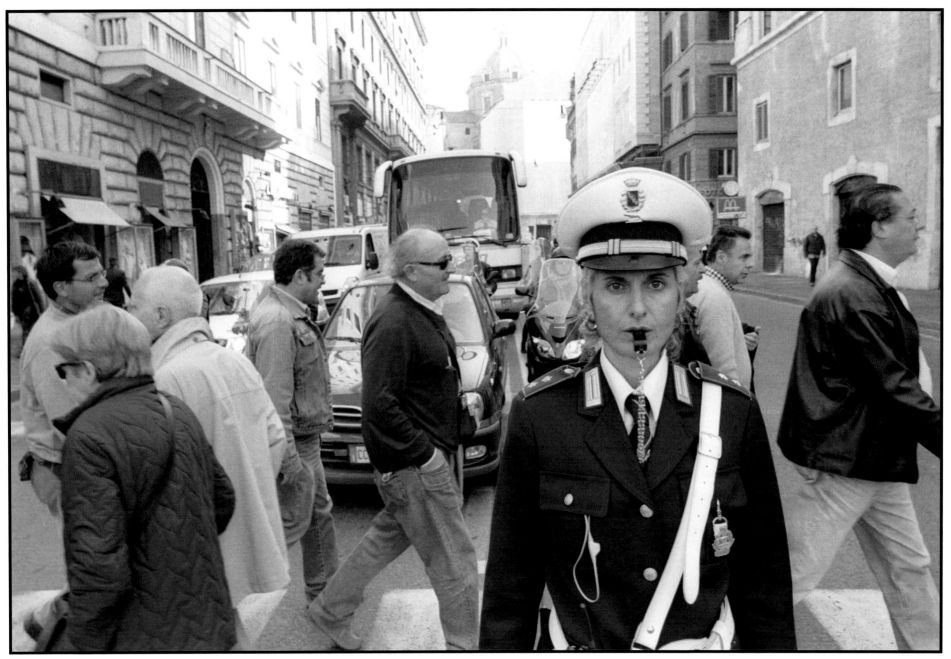

Managing the Crosswalk

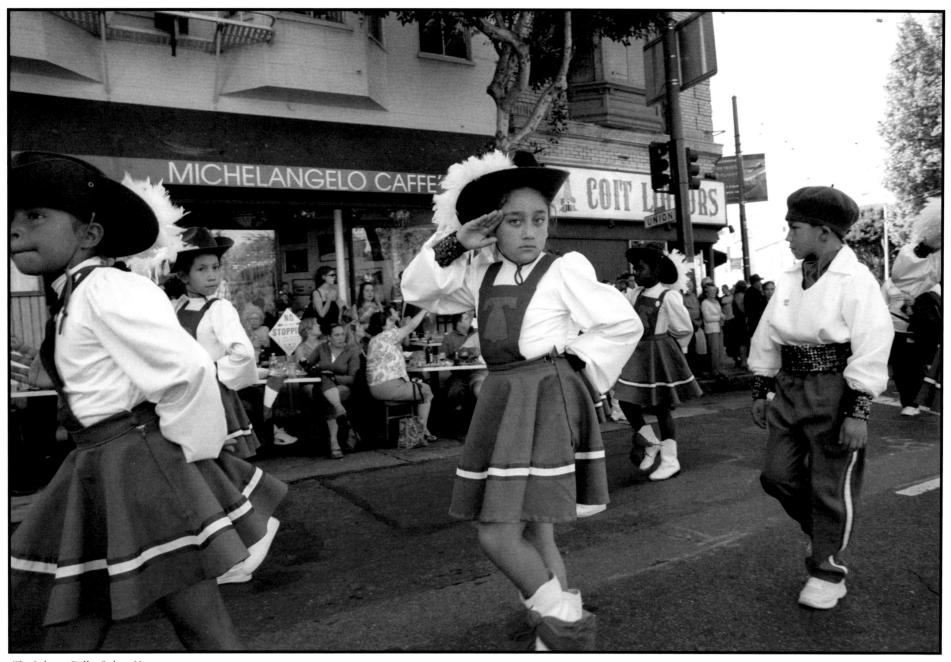

The Liberty Belles Salute You

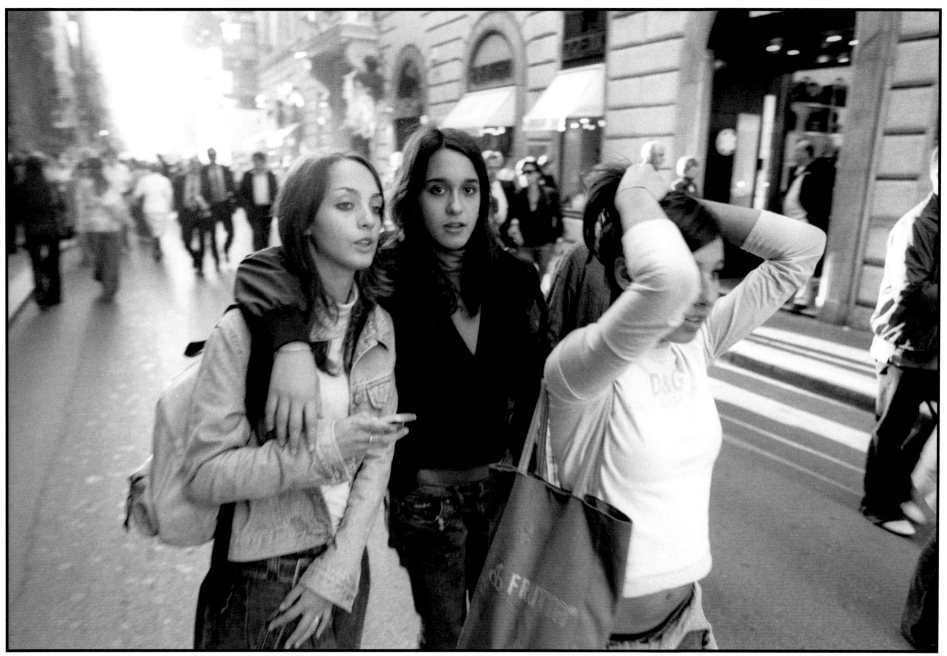

Girlfriends on Via Condotti

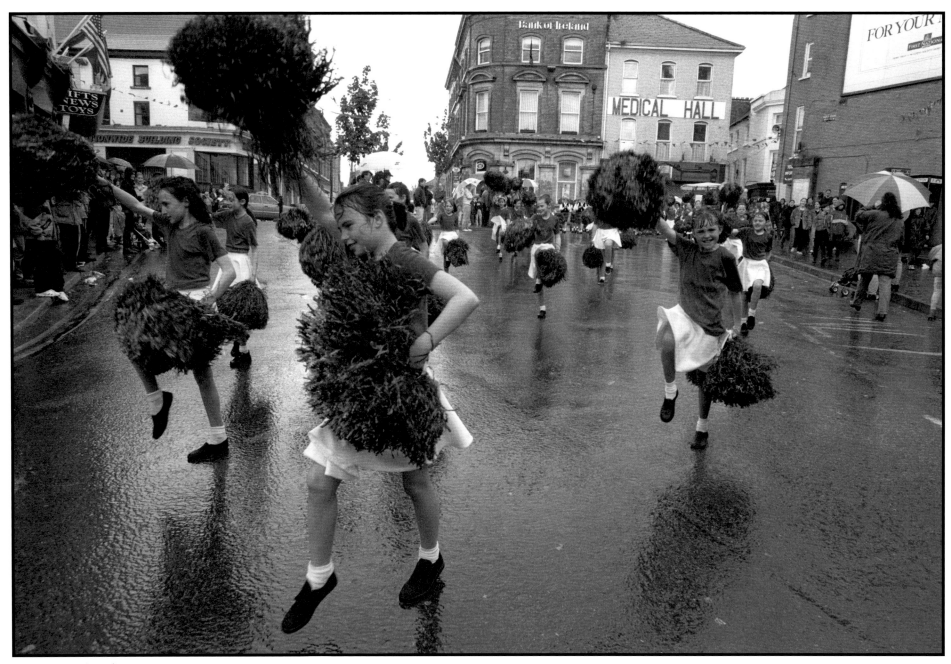

Pom-Pom Girls in the Rain

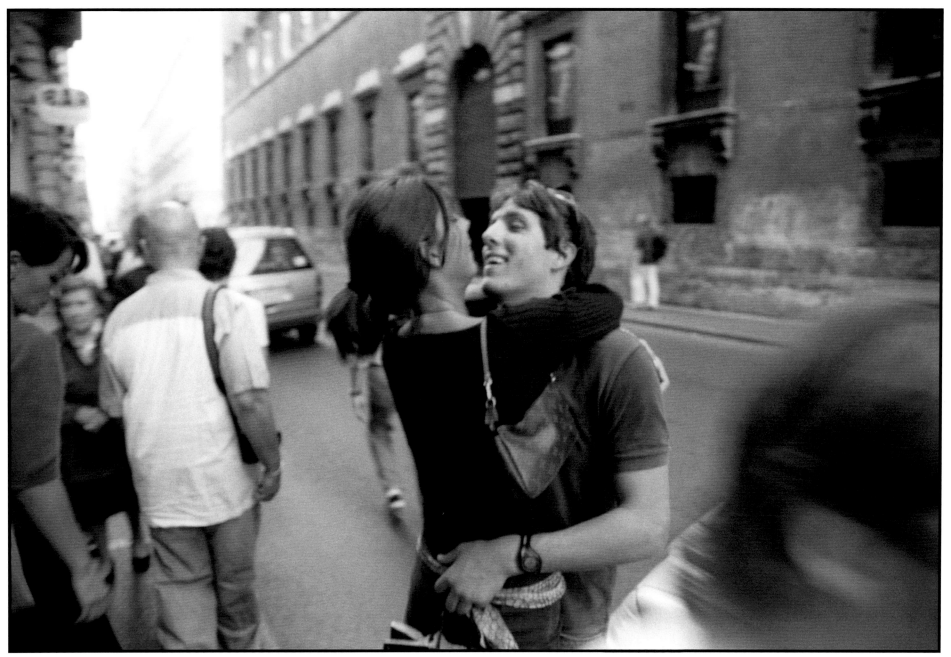

The Embrace

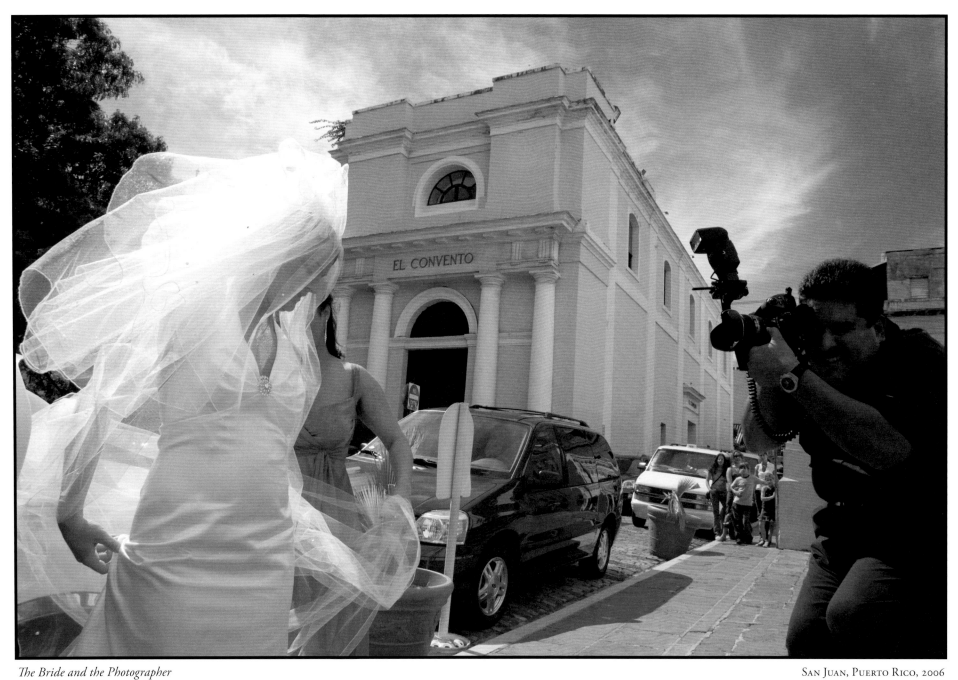

The Bride and the Photographer

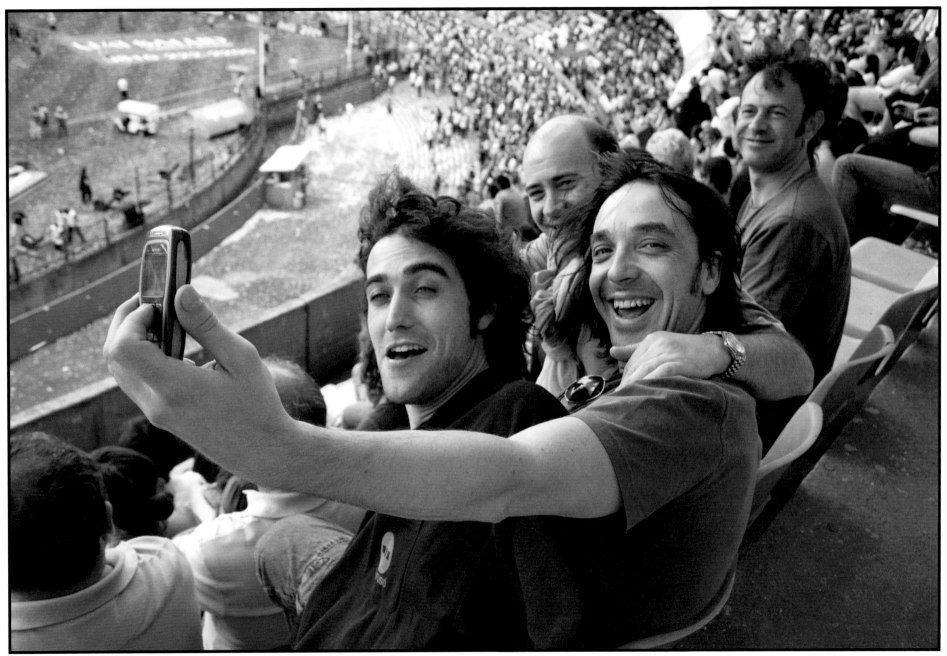

We Were There

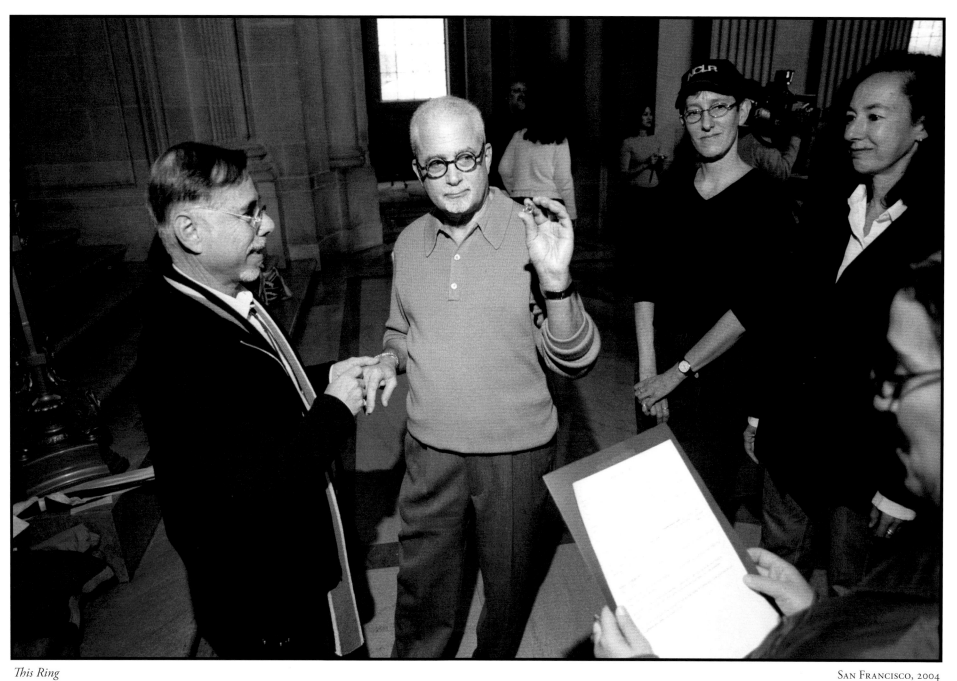

This Ring

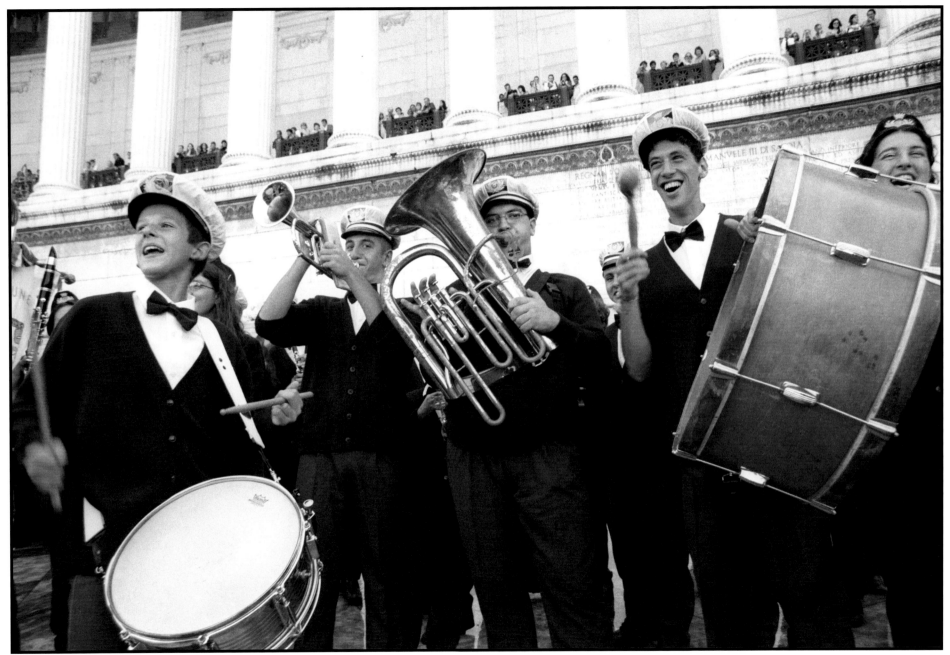

Post-Parade Celebration

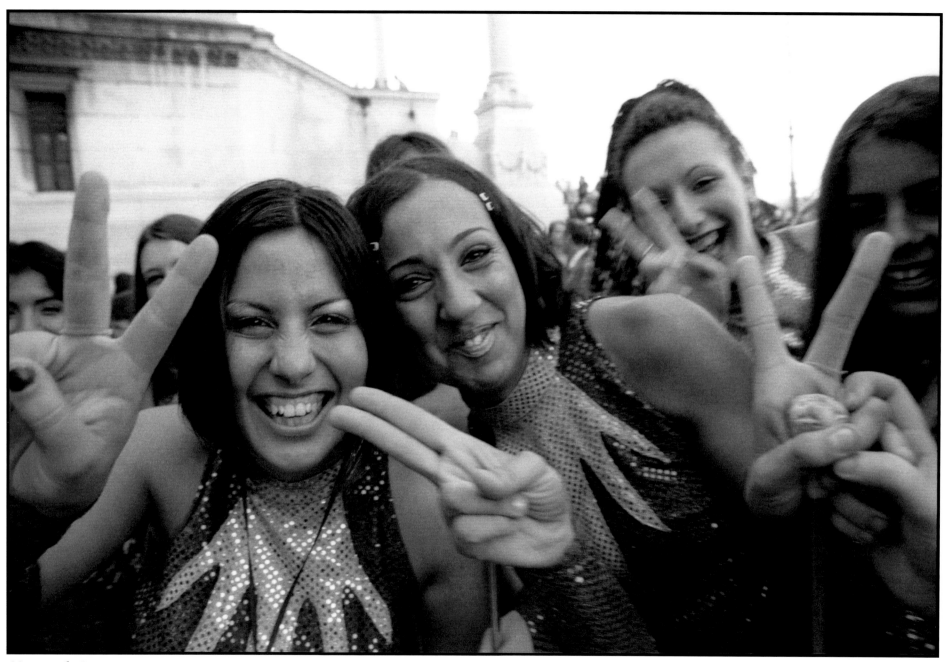

Majorettes for Peace

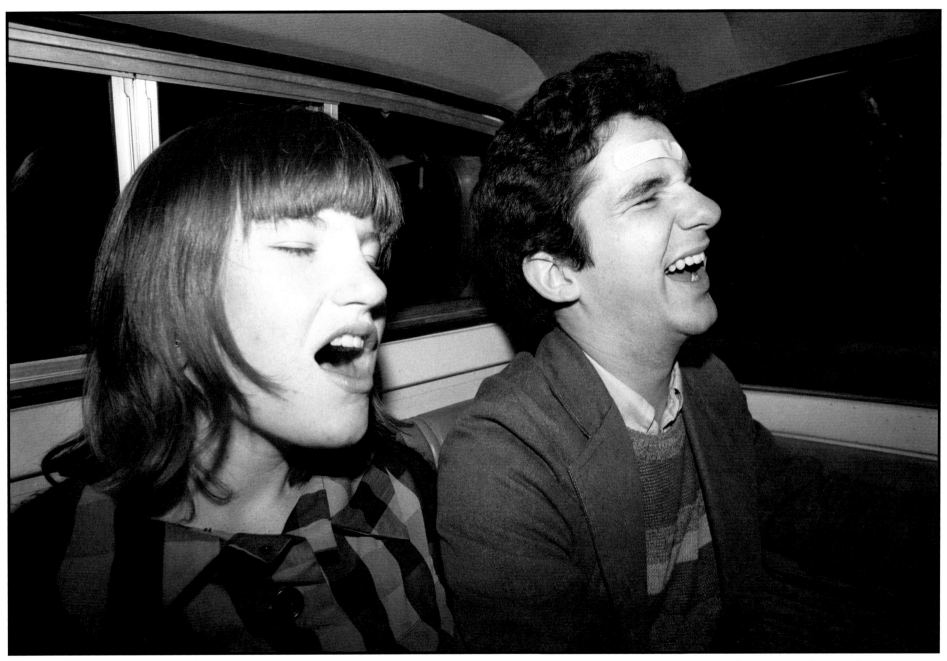

Brenda and Tom, Singing and Laughing

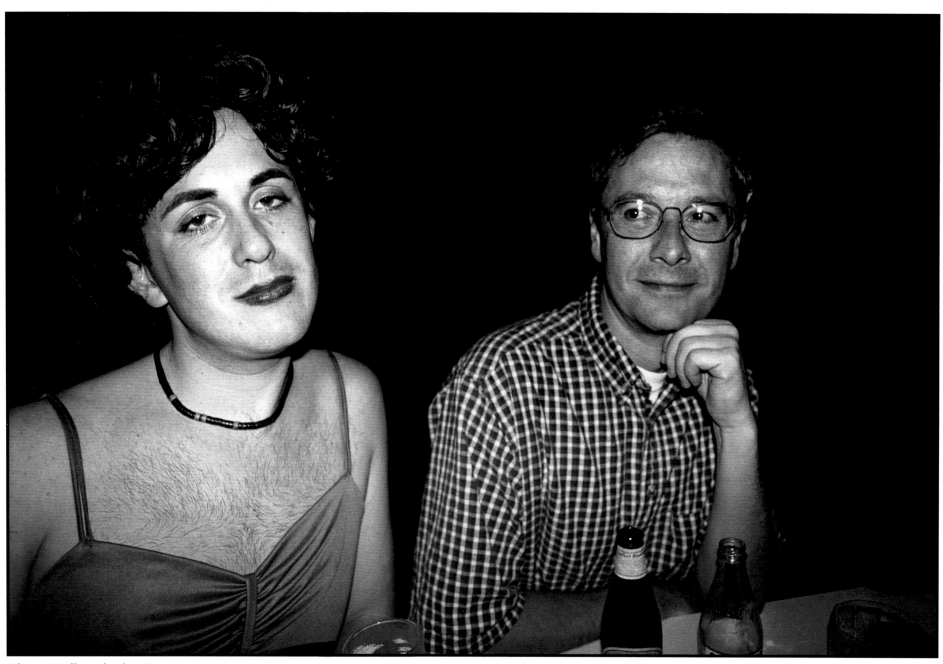

Sharon Needles and Robert T.

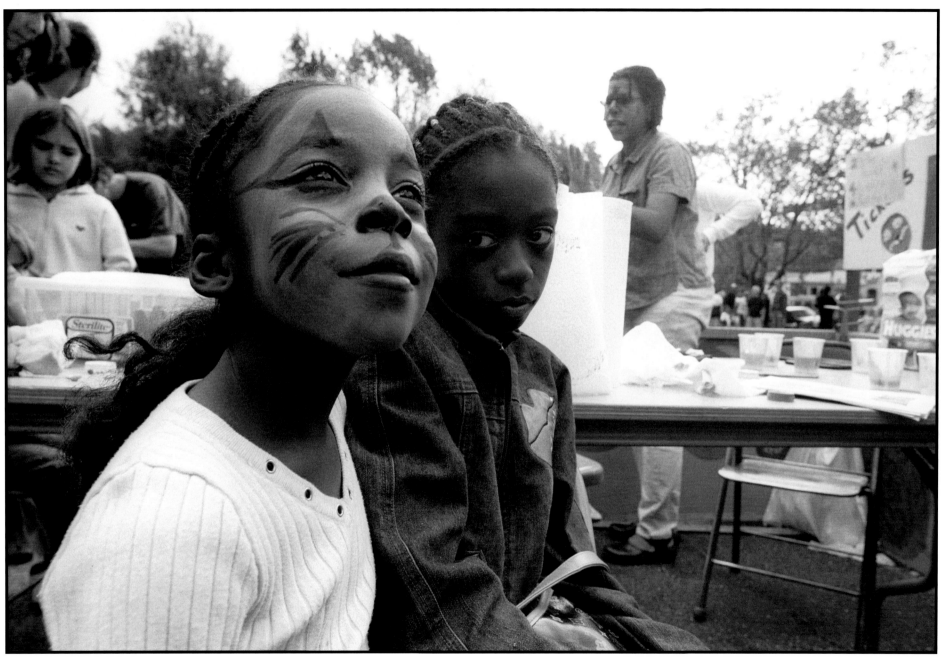

Face Paint Envy

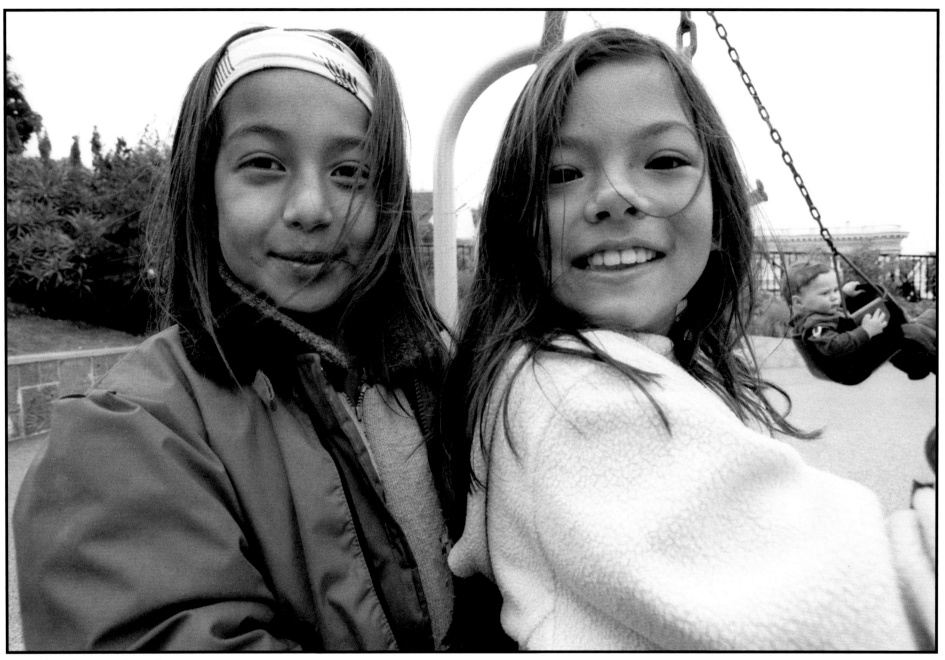

Consuelo and Anna in the Park

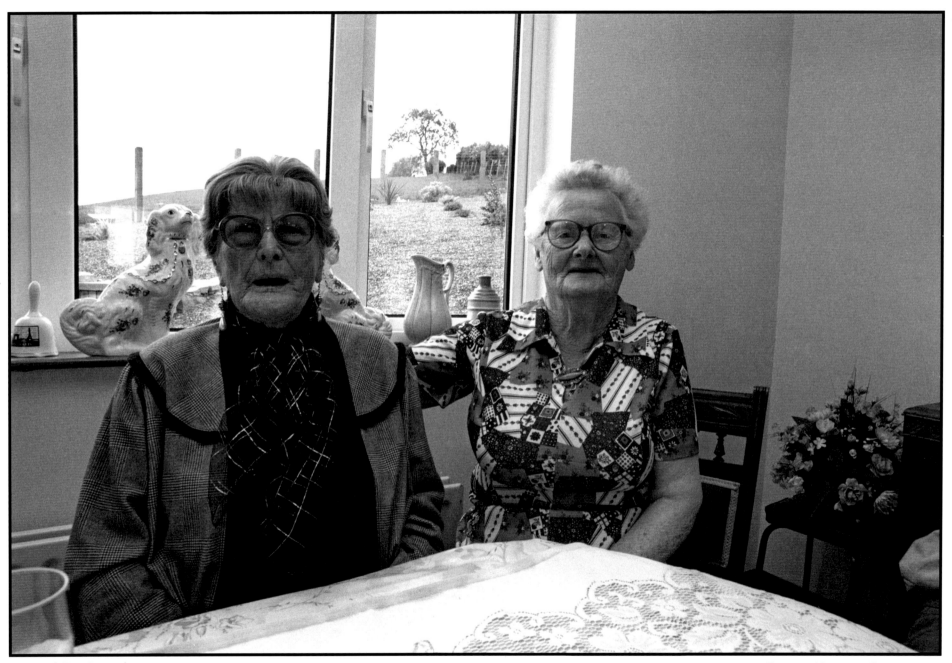

Nan and Kitty Remember ...

FINTONA, NORTHERN IRELAND, 1995

81

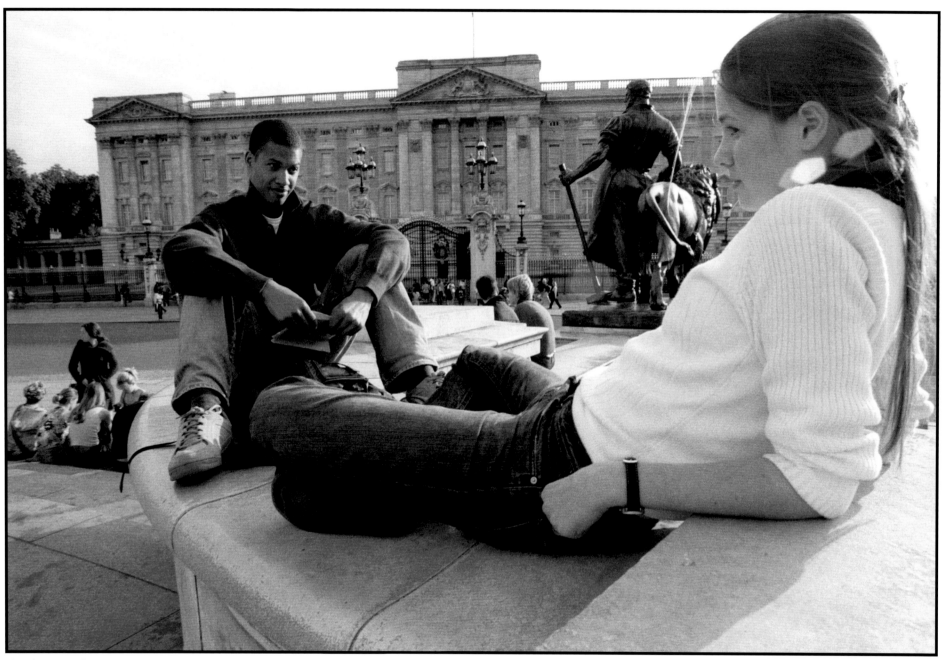

On the Verge of Yes

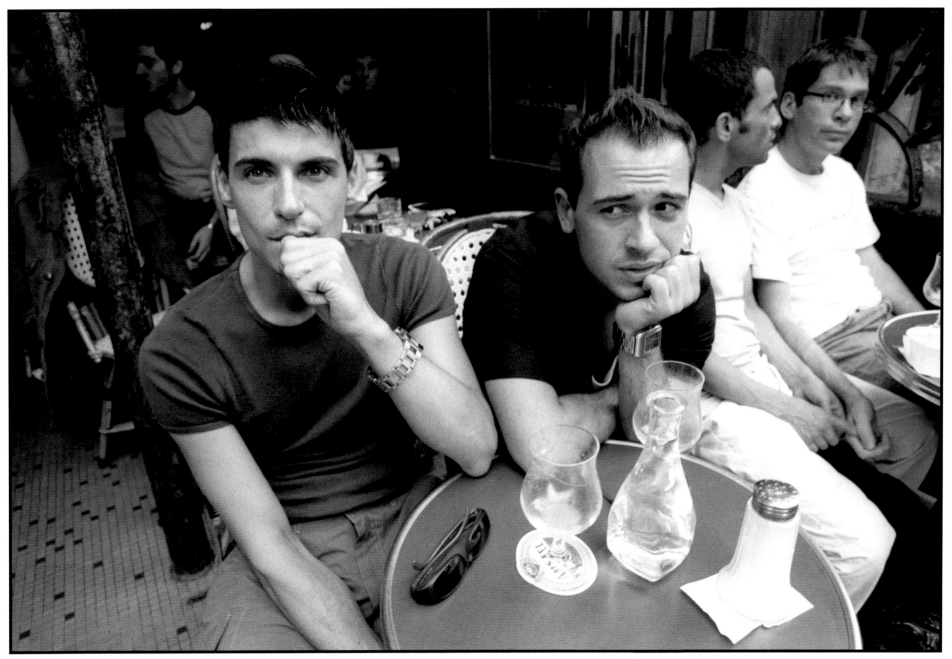

Waiting for Something to Happen

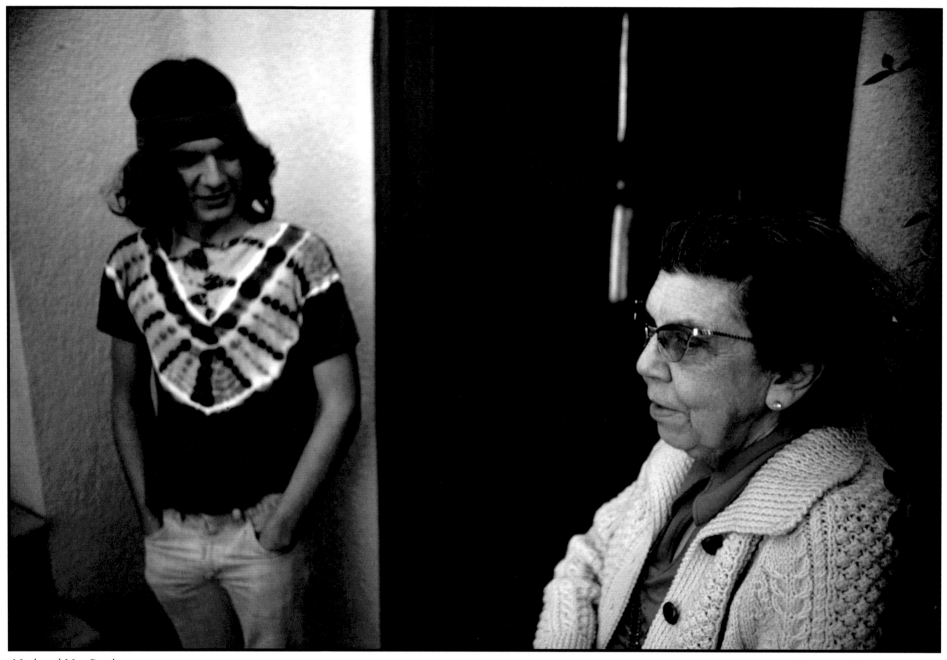

Mark and Mrs. Pearl

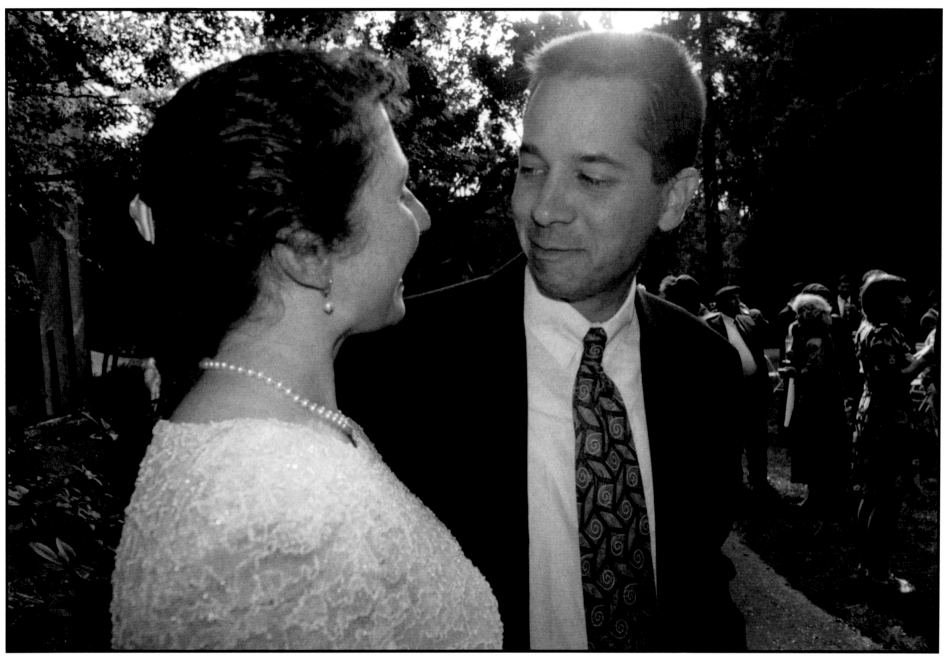

In Love at Friends' Wedding

Berkeley, California, 1996

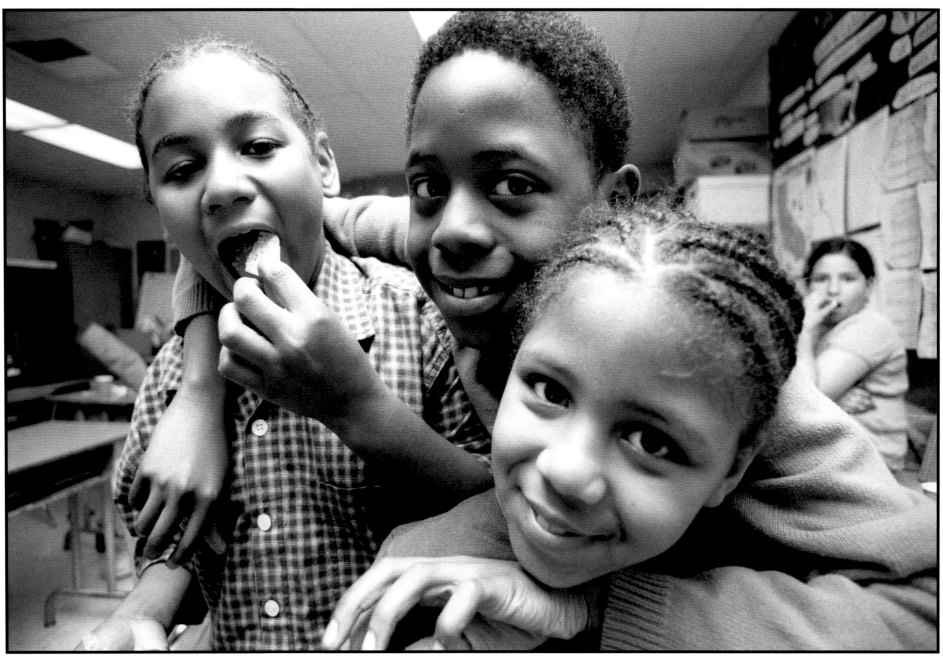

When Fifth Graders Visit Their Fourth-Grade Teacher

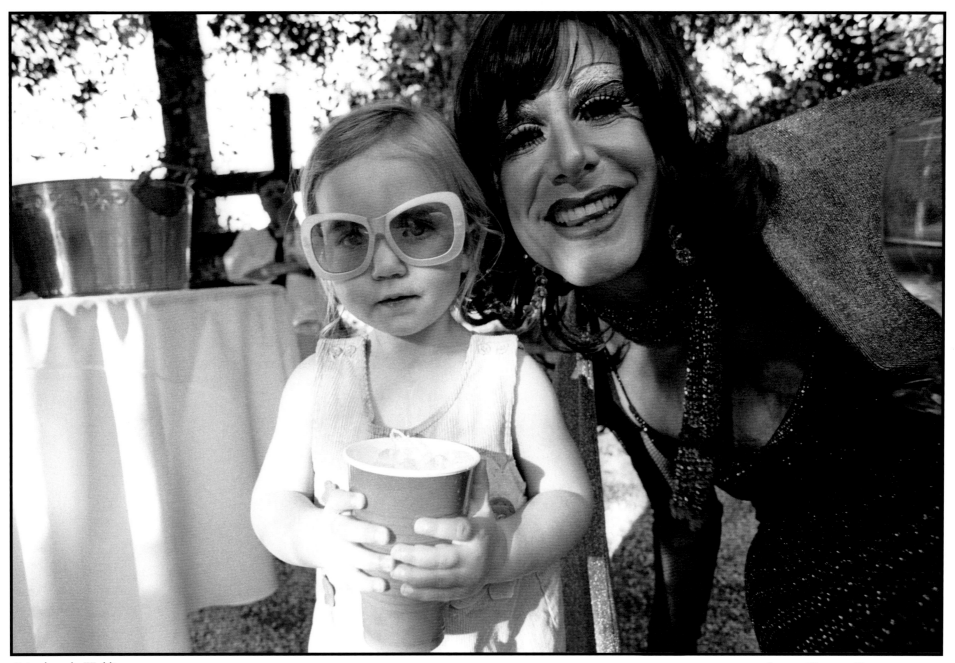

Friends at the Wedding

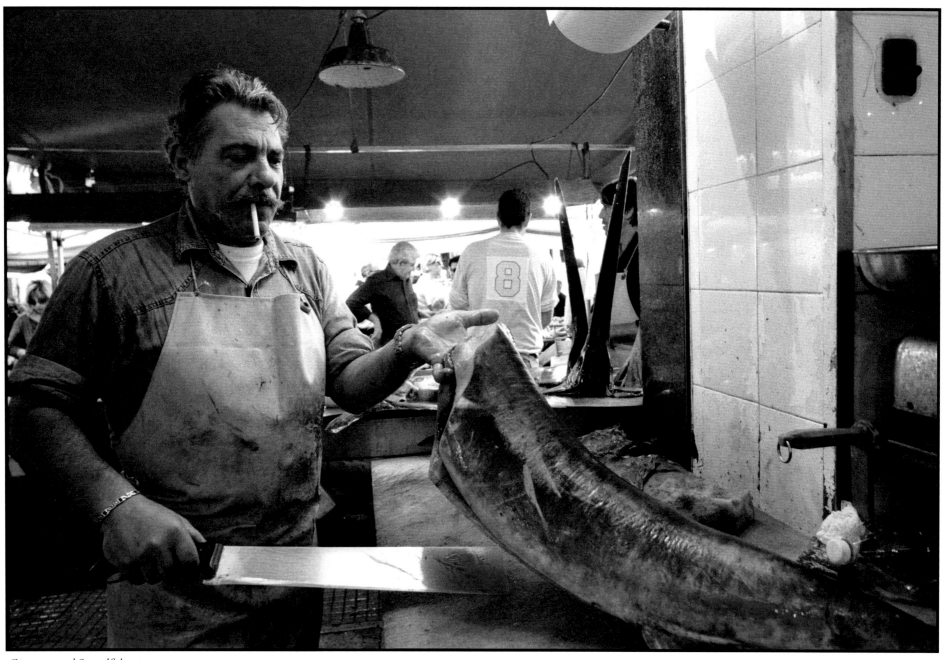

Cigarette and Swordfish

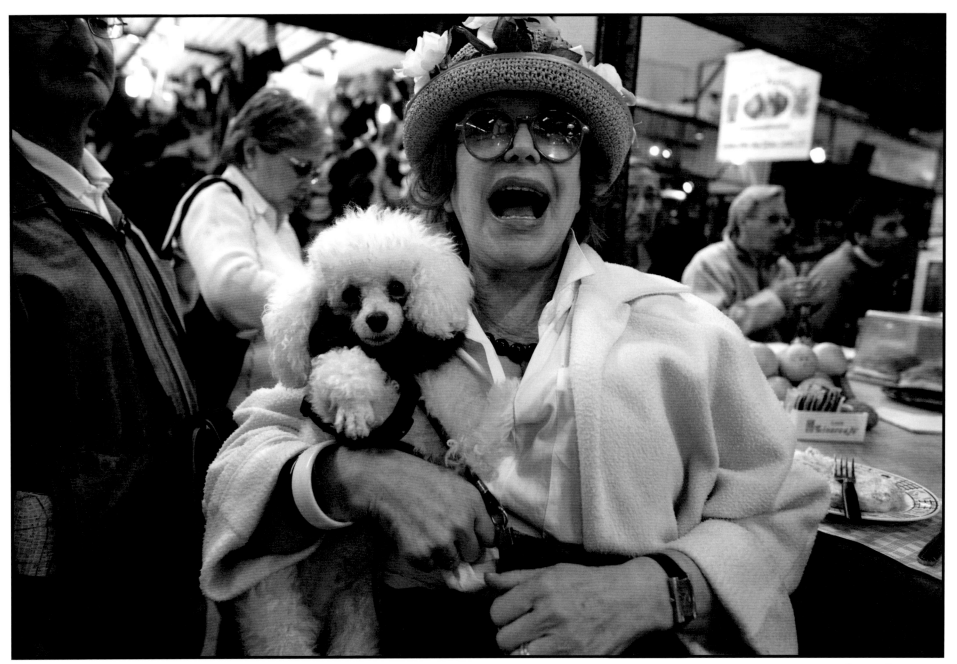

Two Poodles

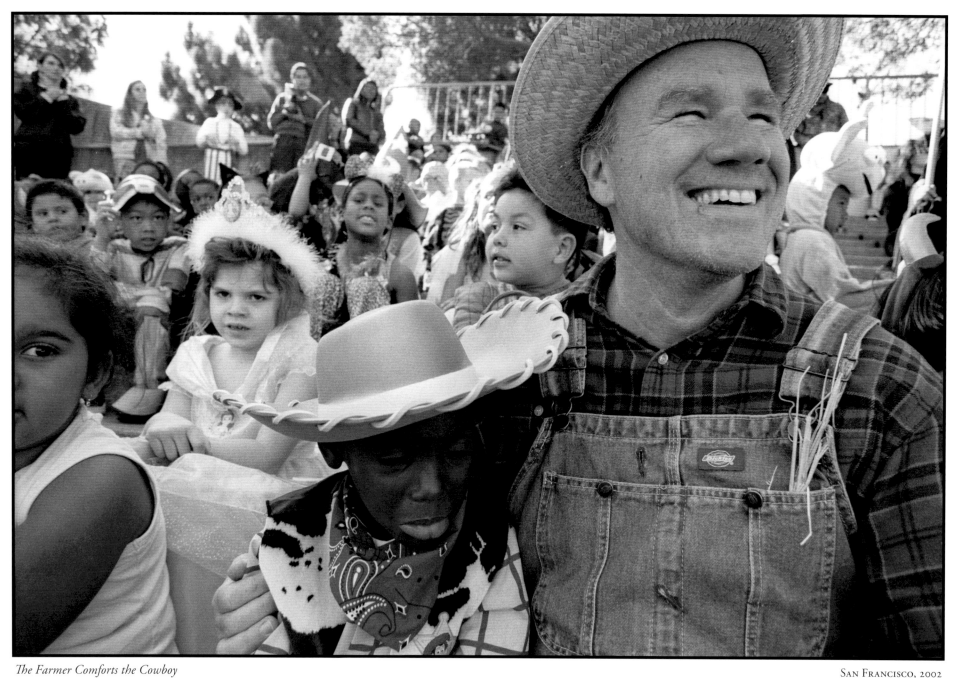

The Farmer Comforts the Cowboy

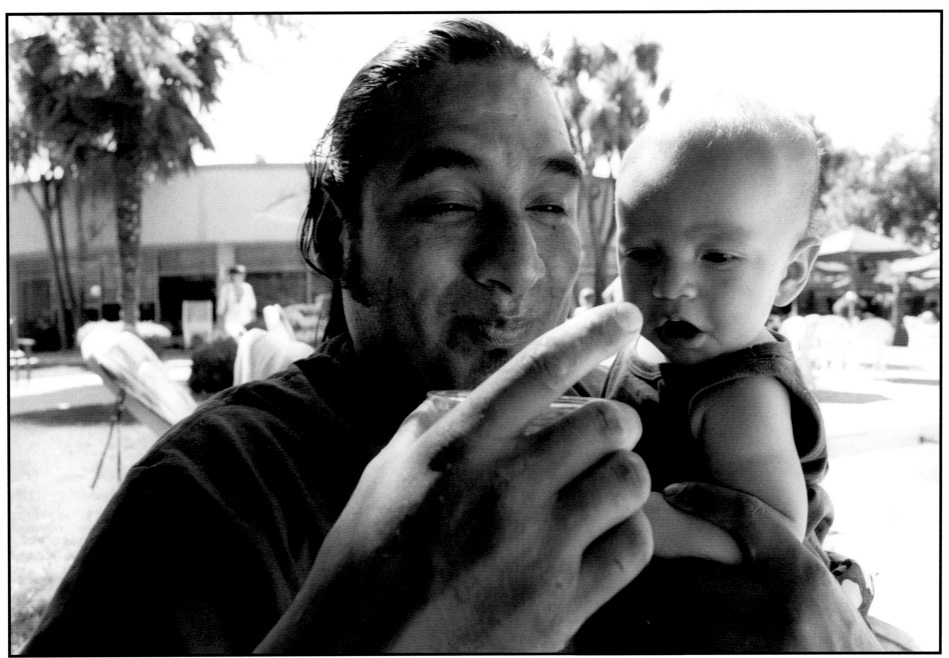

Trigonometry

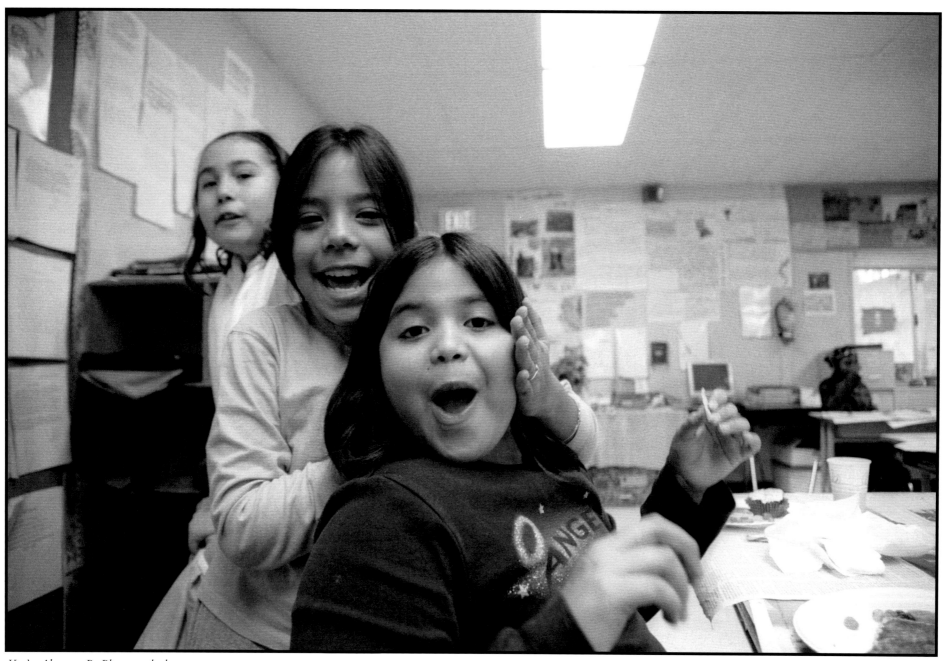

You're About to Be Photographed

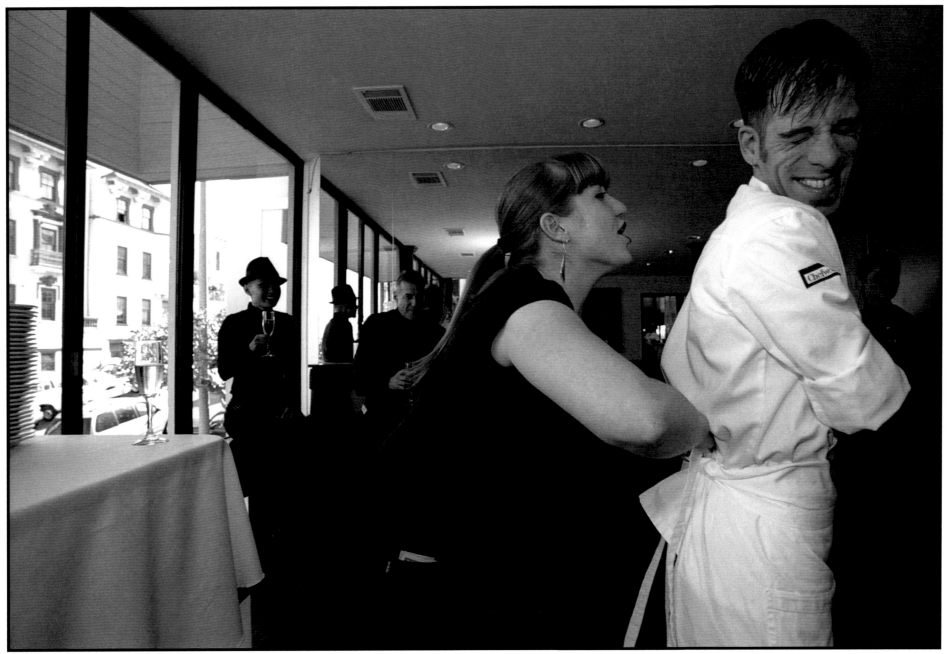

Tied Tight at Opening

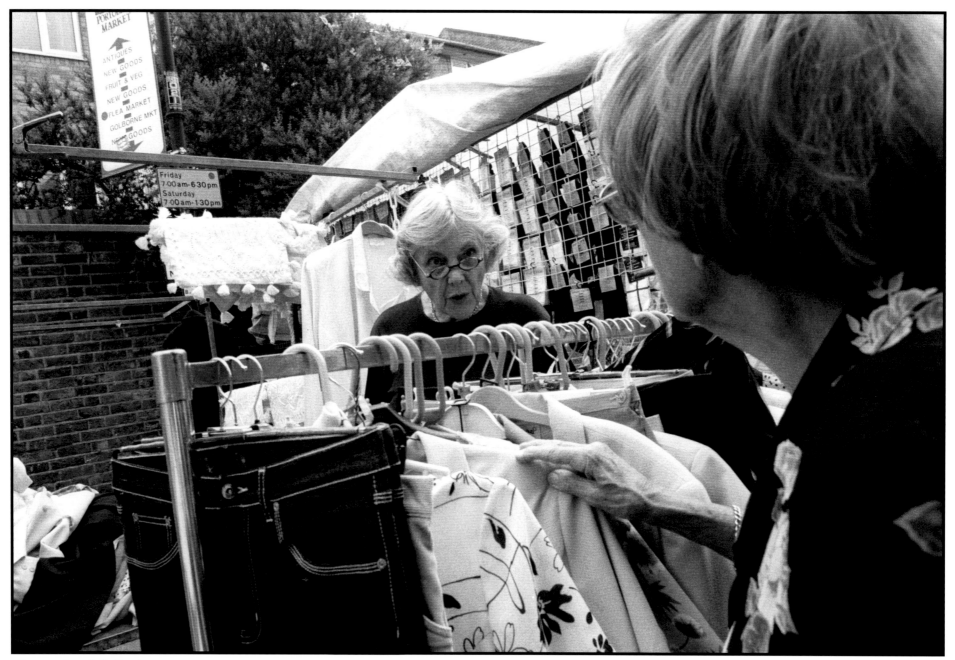

Gossip on Portobello Road

London, 2002

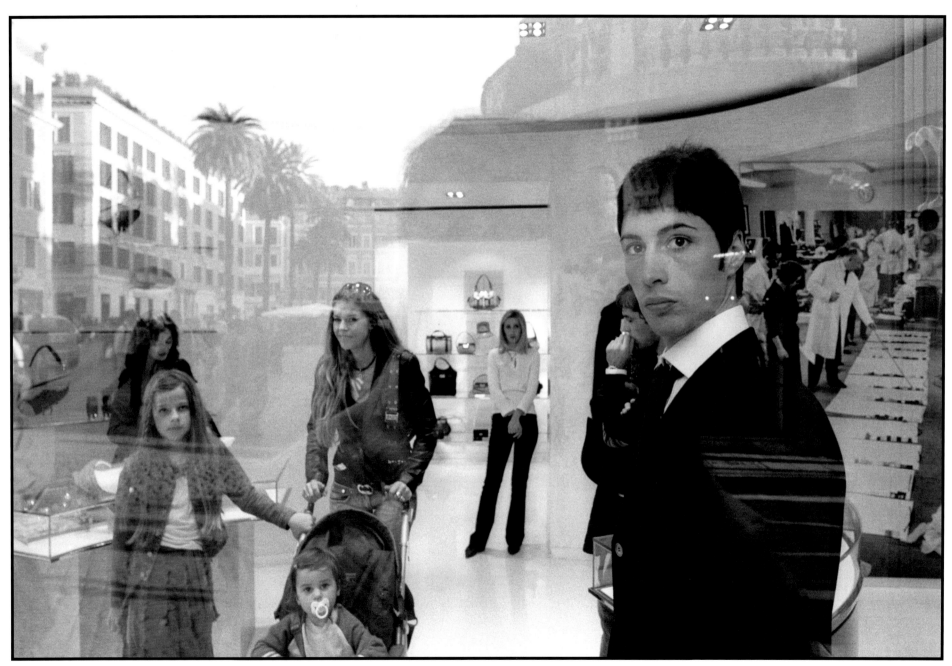

Purse Shop

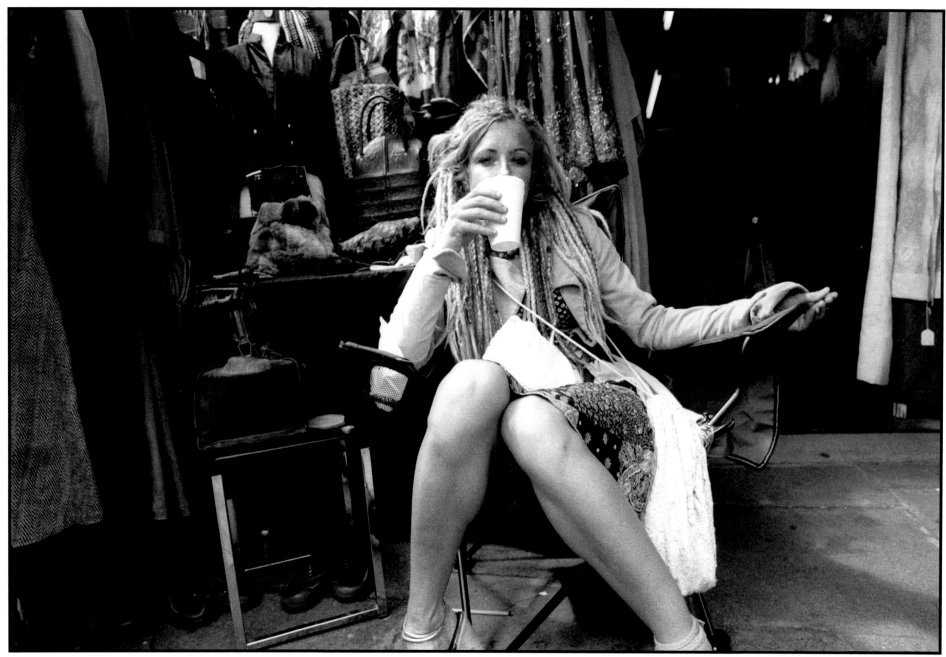

Cup of Coffee and a Pair of Legs

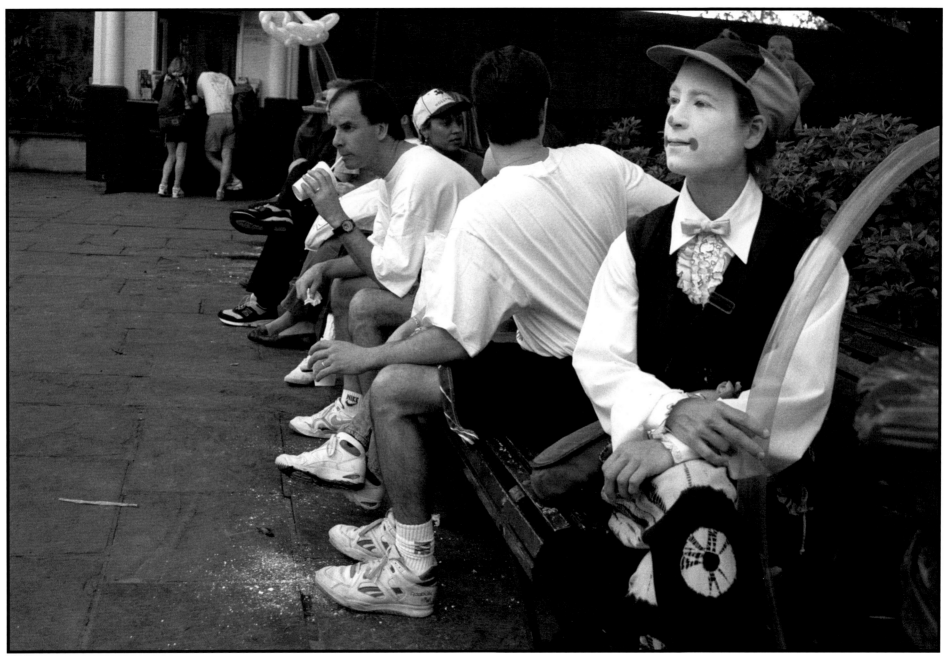

Balloon Mime Gets No Break

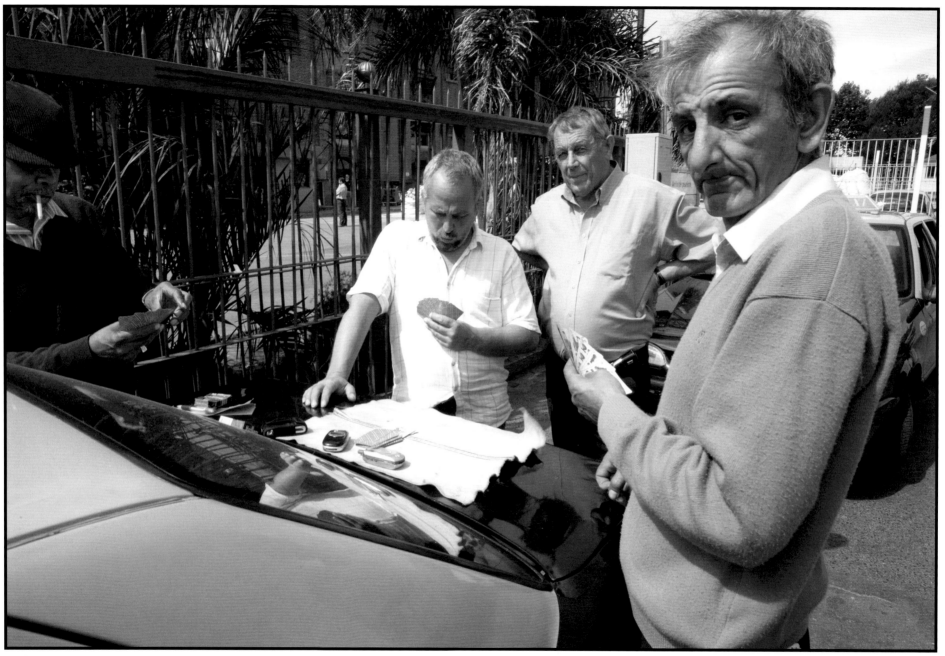

Cab Driver Card Game

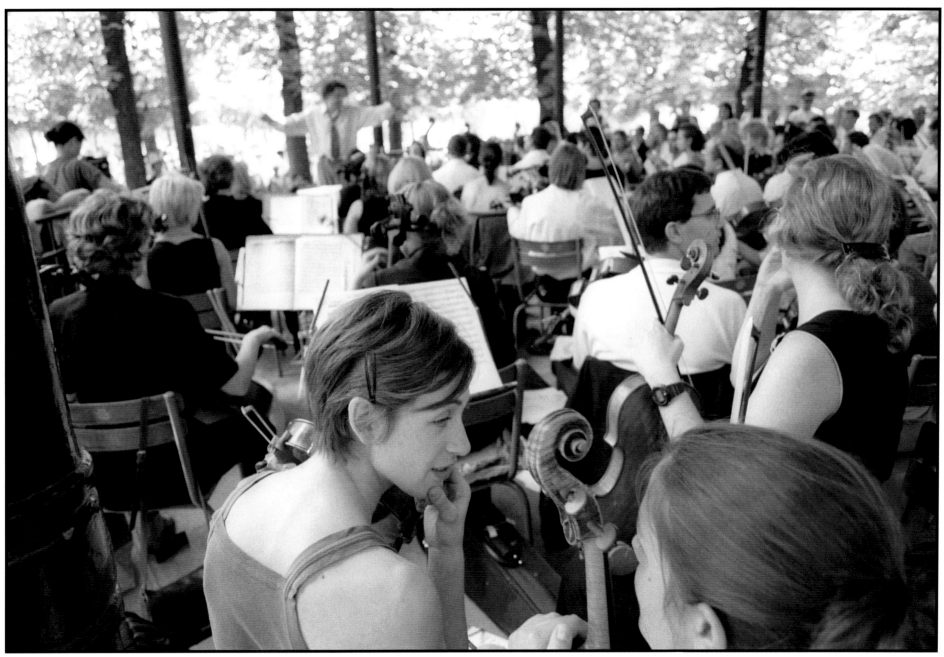

Mid-Performance Considerations

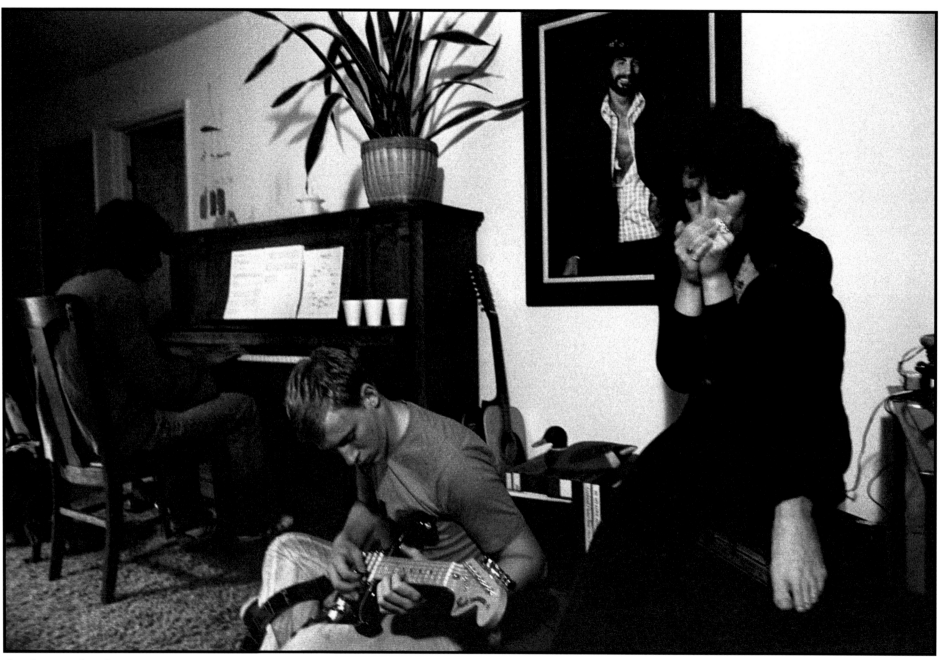

Jam Session at Peggy's

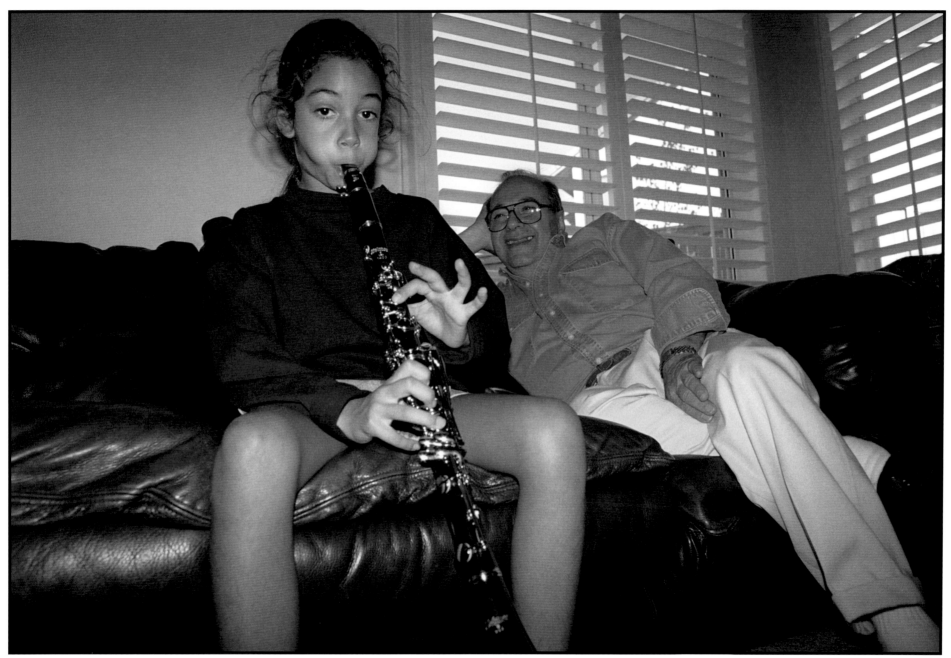

Clarinet Recital

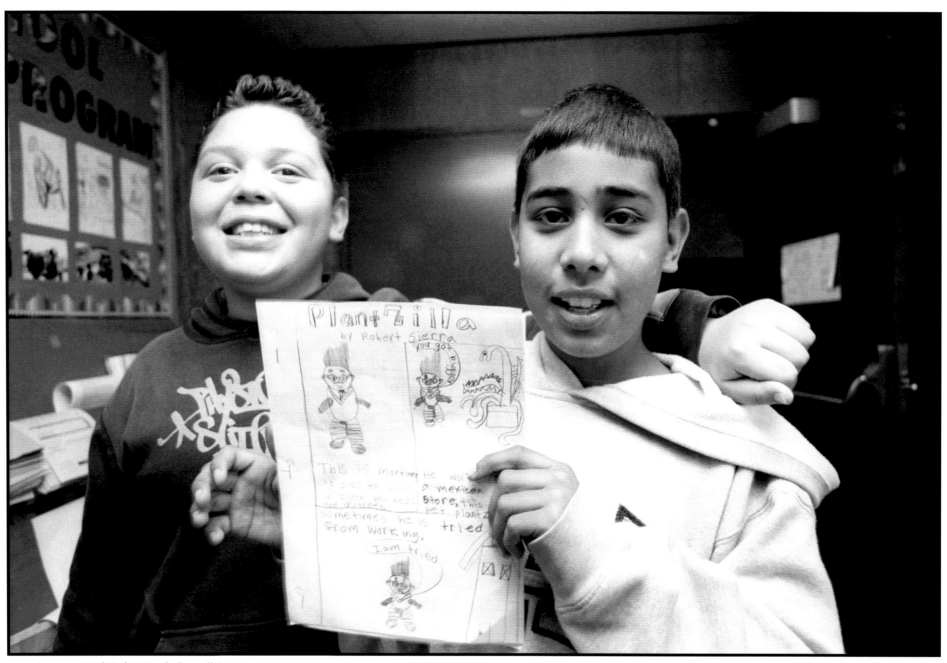

Jonathan Poses with Robert (and Plantzilla)

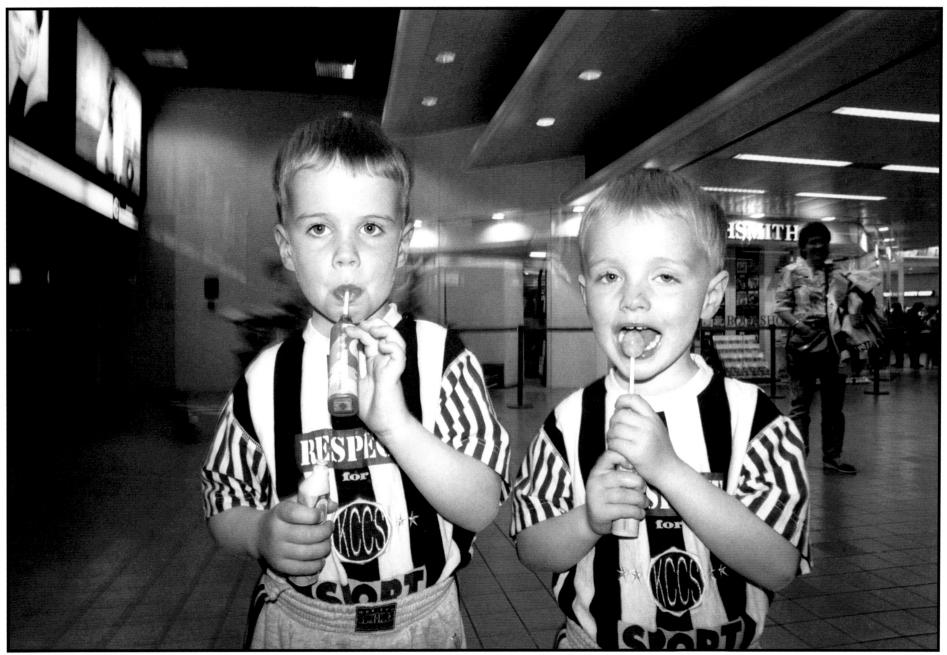

Battery-Powered Lollies

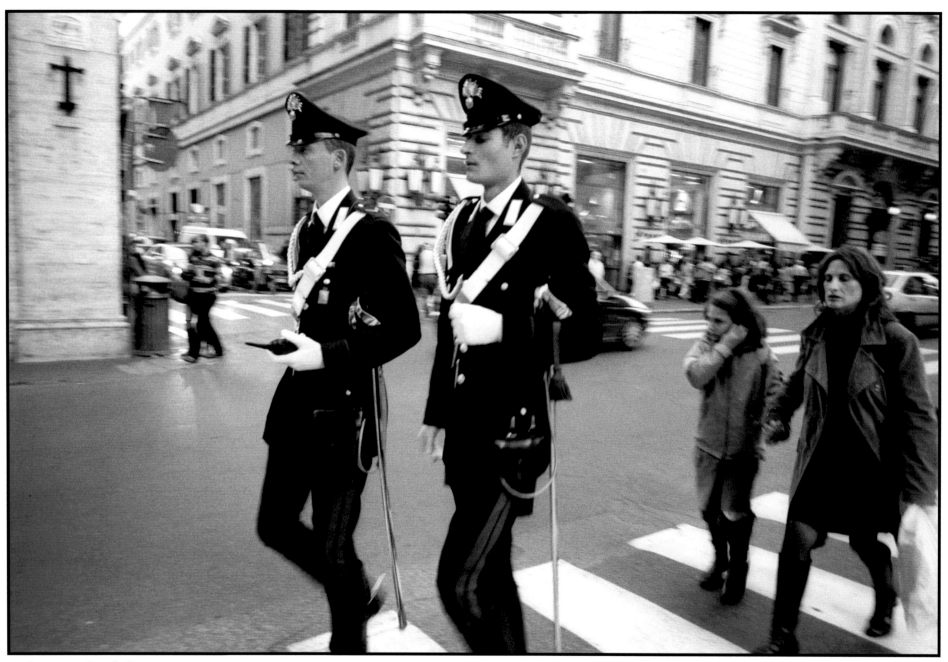

Parliamentary Guards Crossing

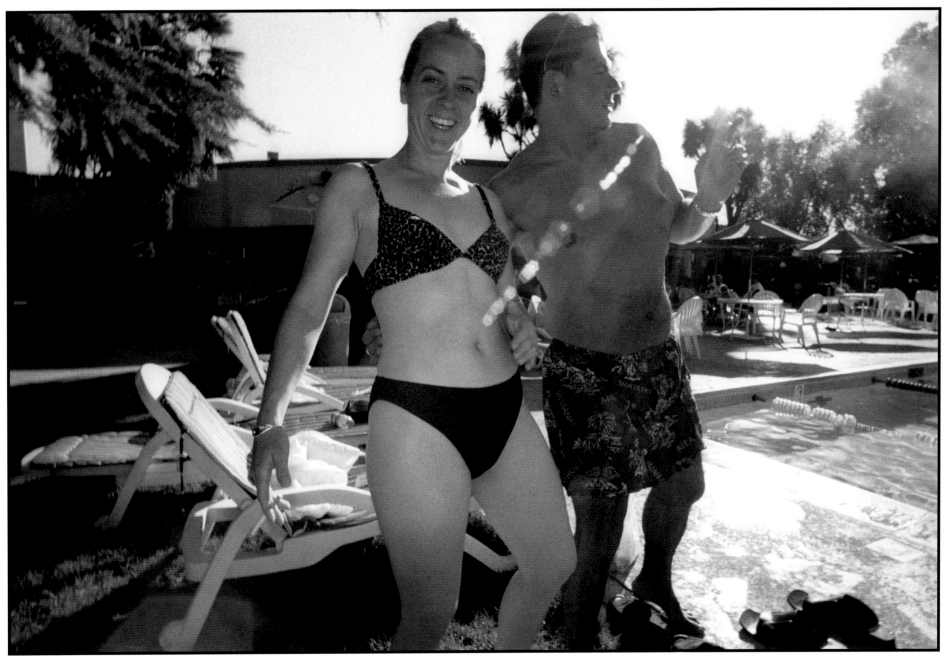

Maybe a Swim

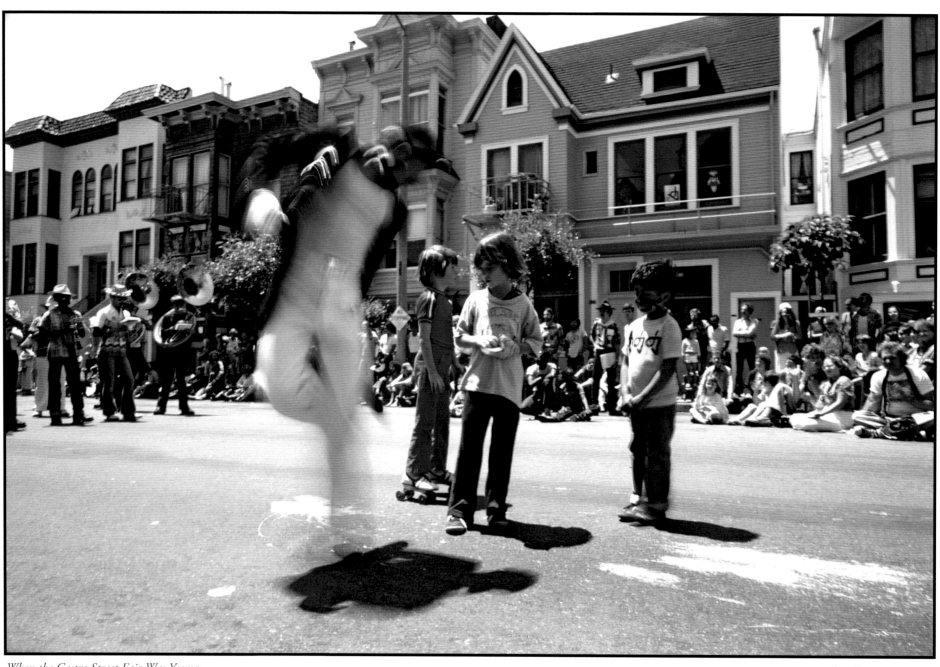

When the Castro Street Fair Was Young

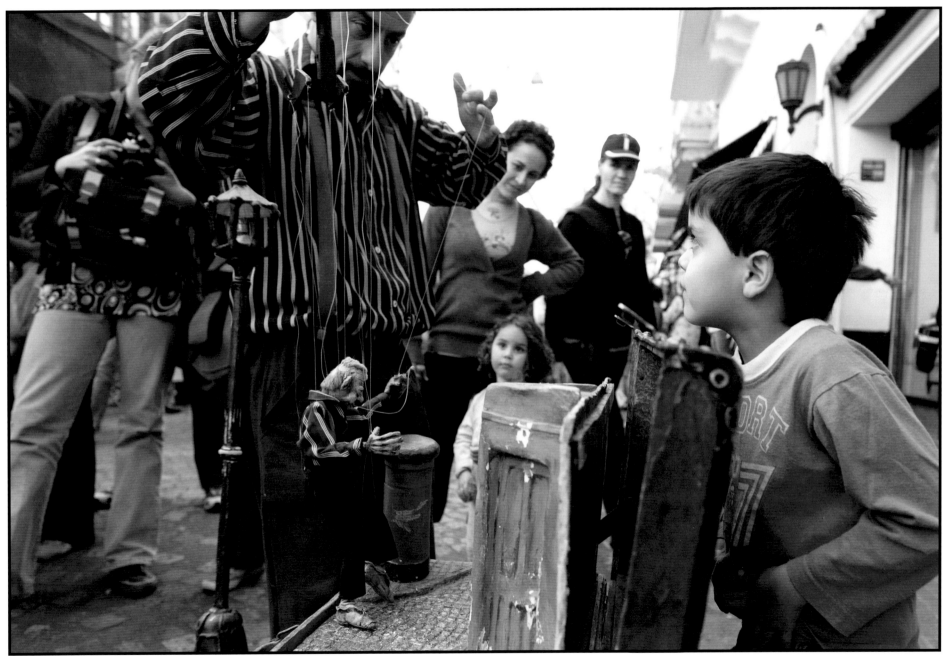

Around the Fourth Wall

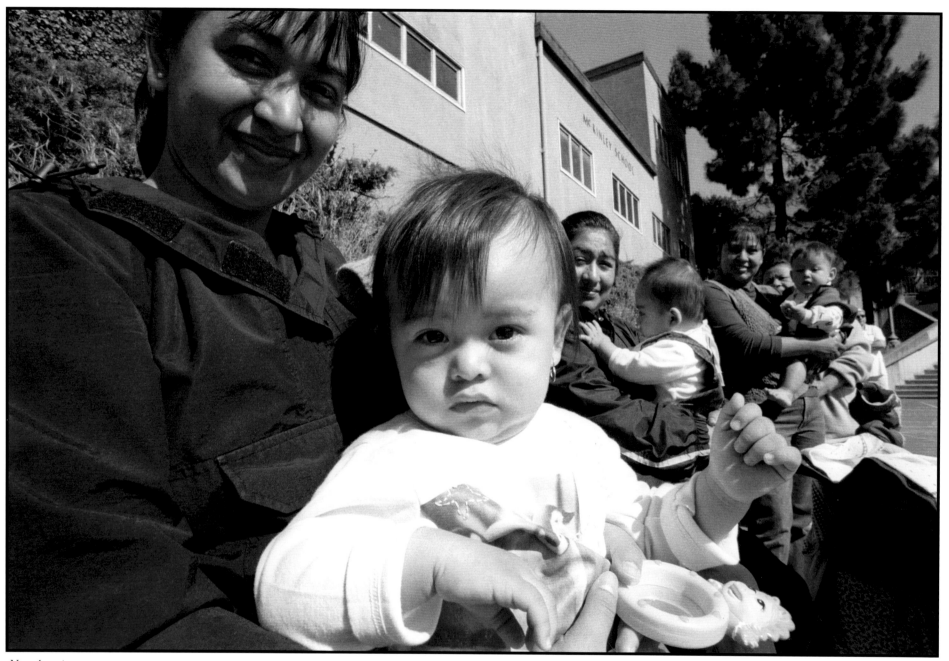

New Americans

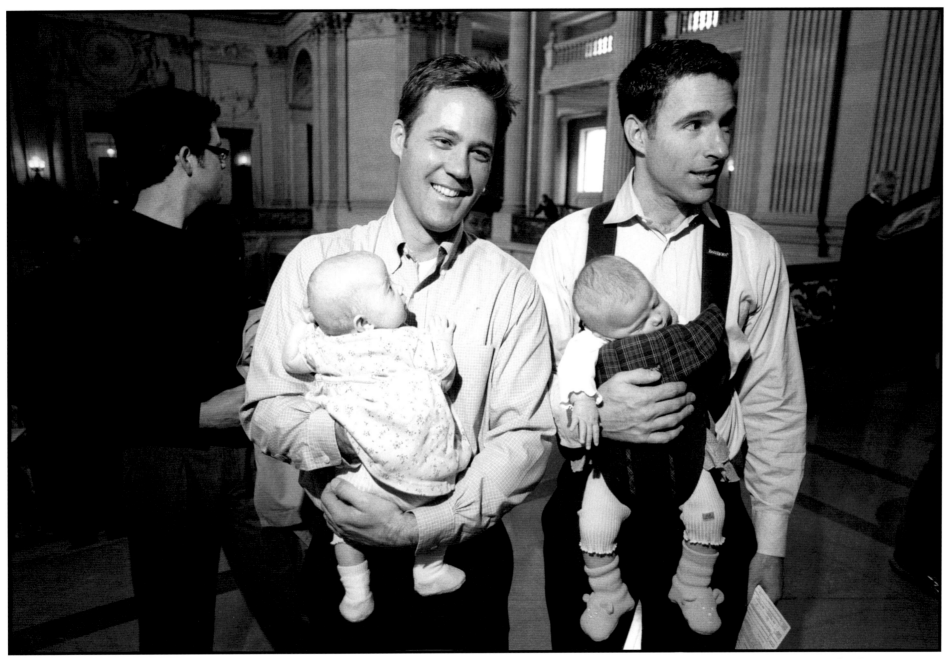

Husbands and Sisters

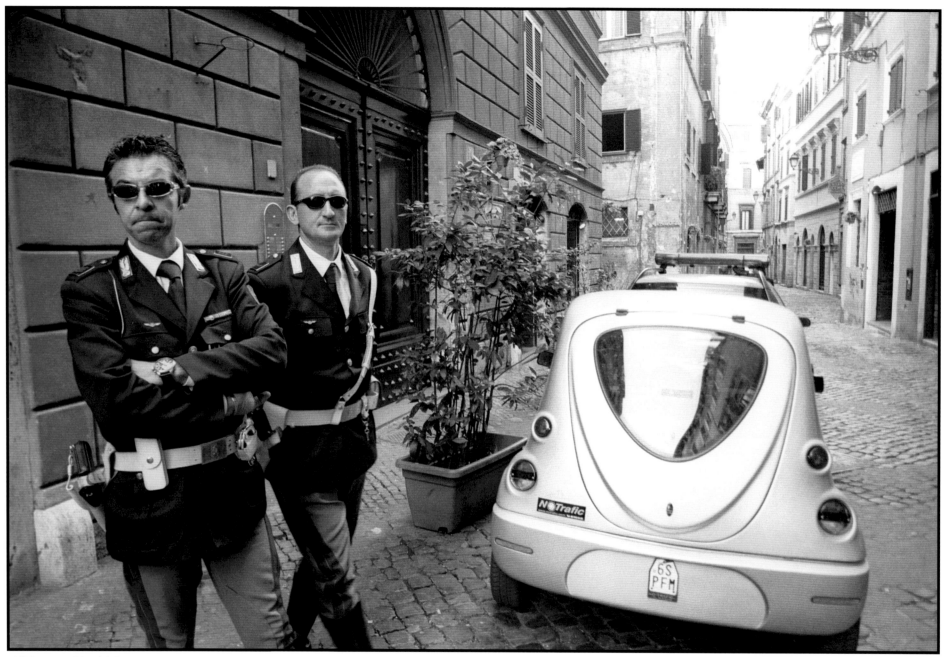

All Quiet on Via del Orso

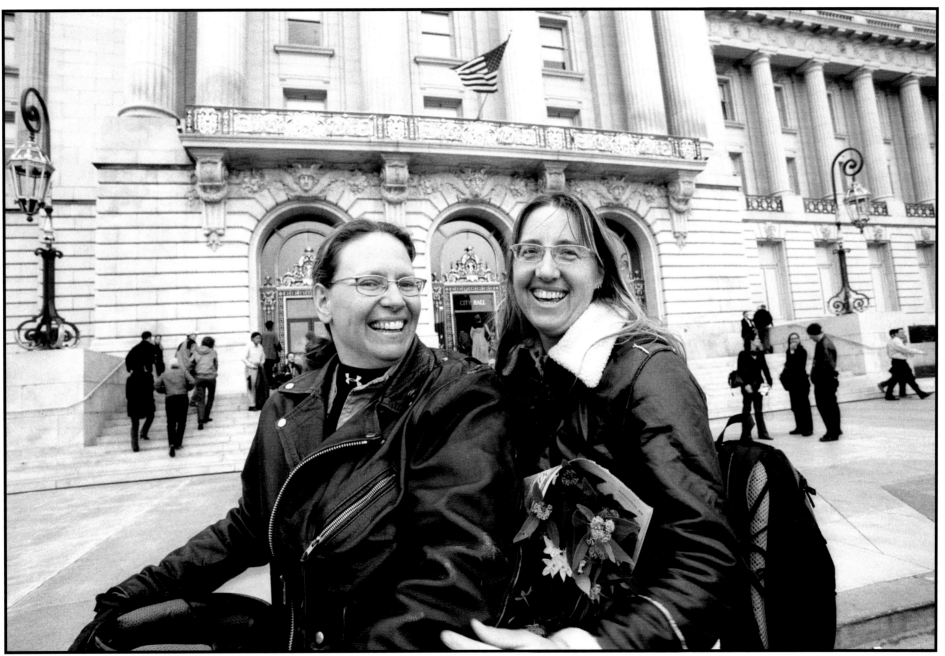

Just Married

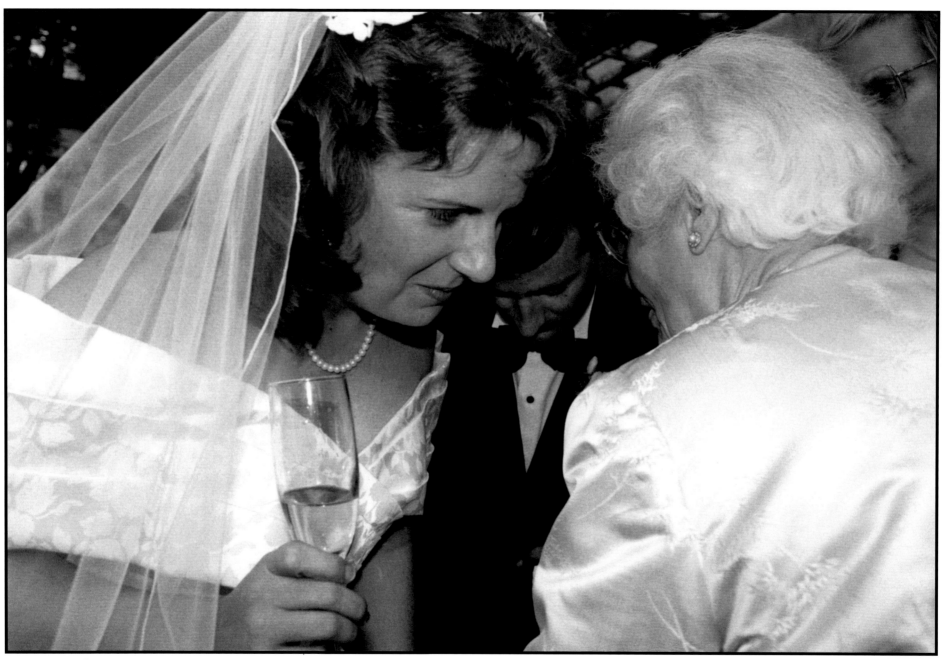

Last-Minute Advice

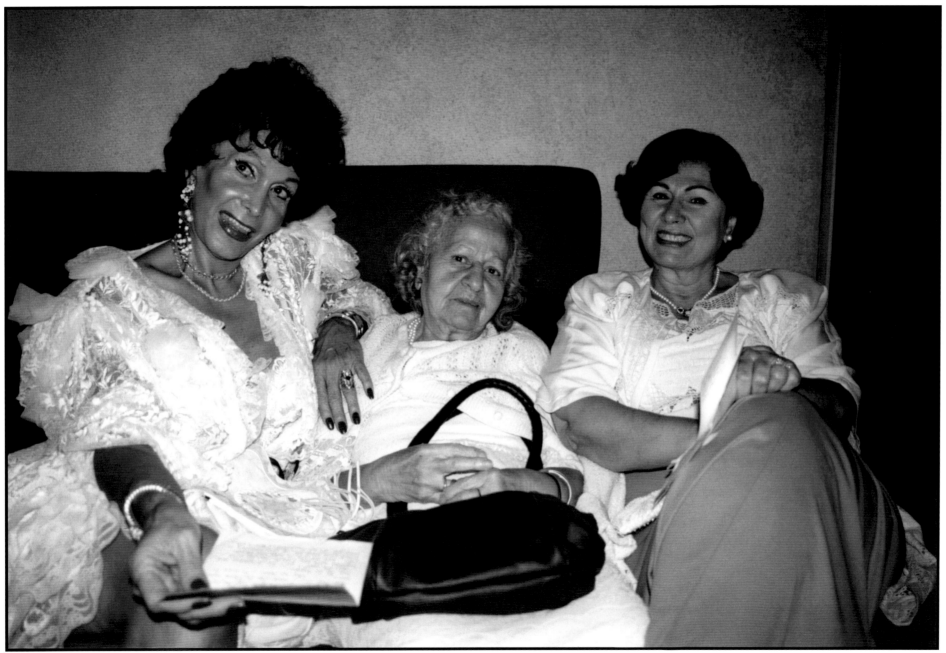

Monique's Letter

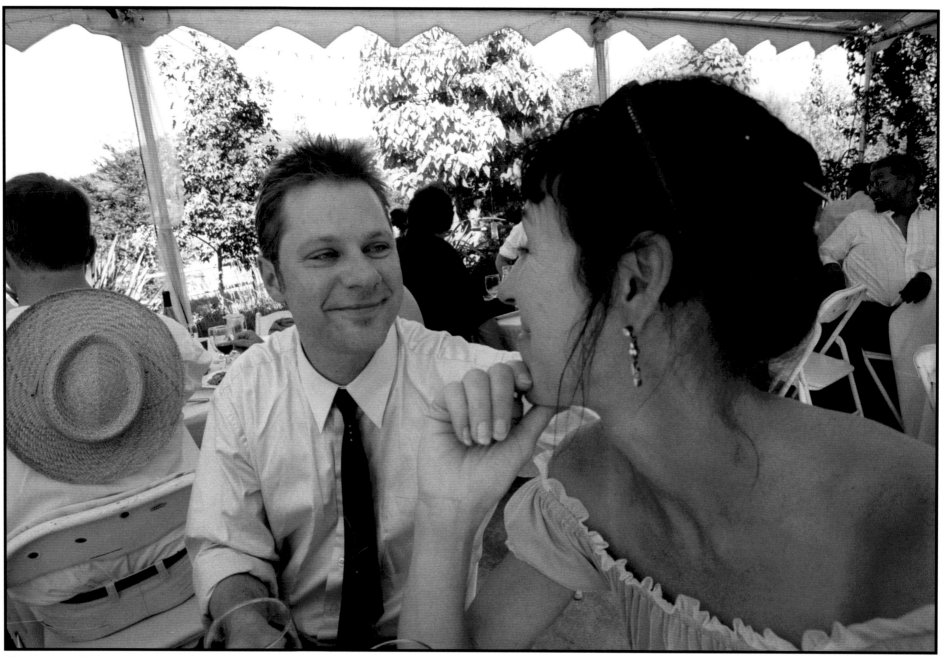

The Groom and Sister June

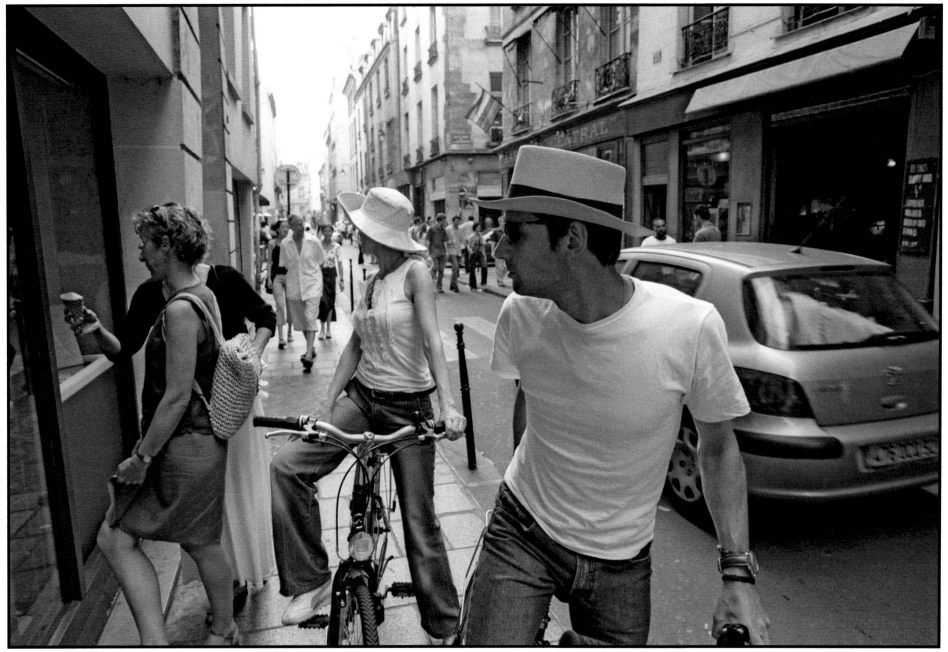

Window Shopping by Bicycle

Paris, 2003

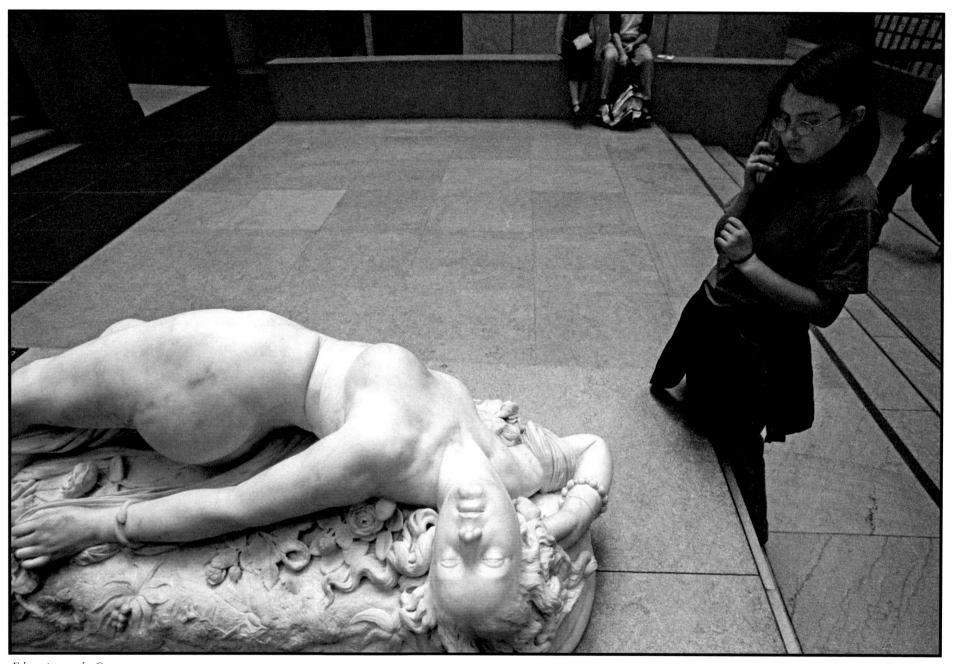

Education at the Orsay

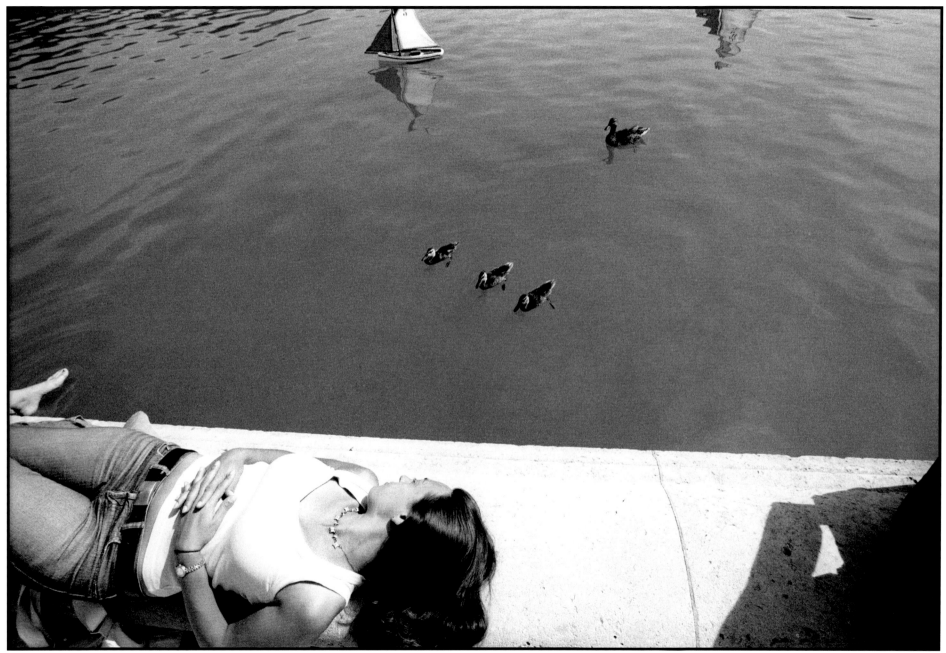

A Lovely Day for Baby Ducks

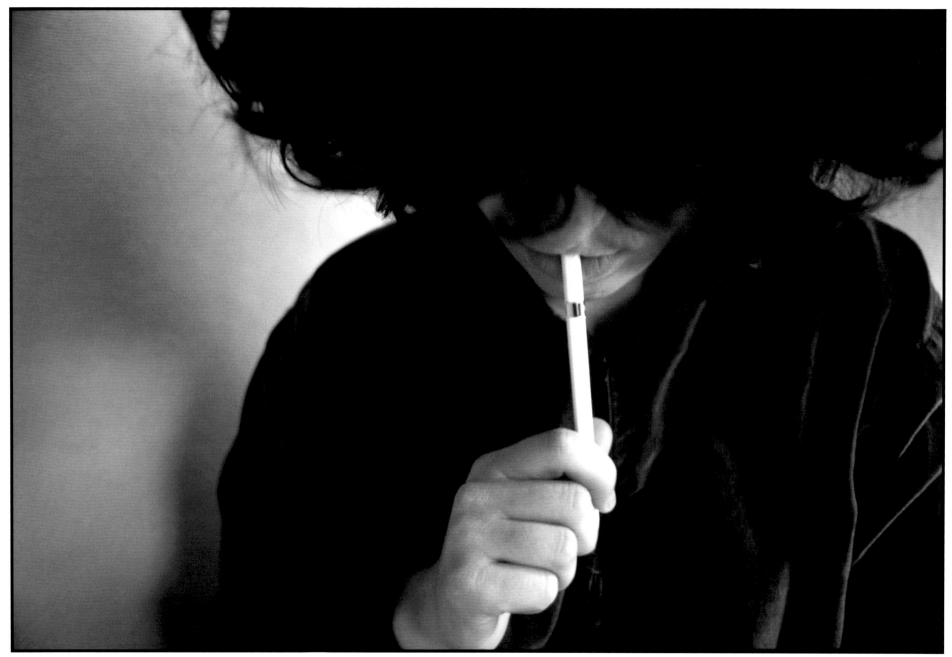

Close Reading

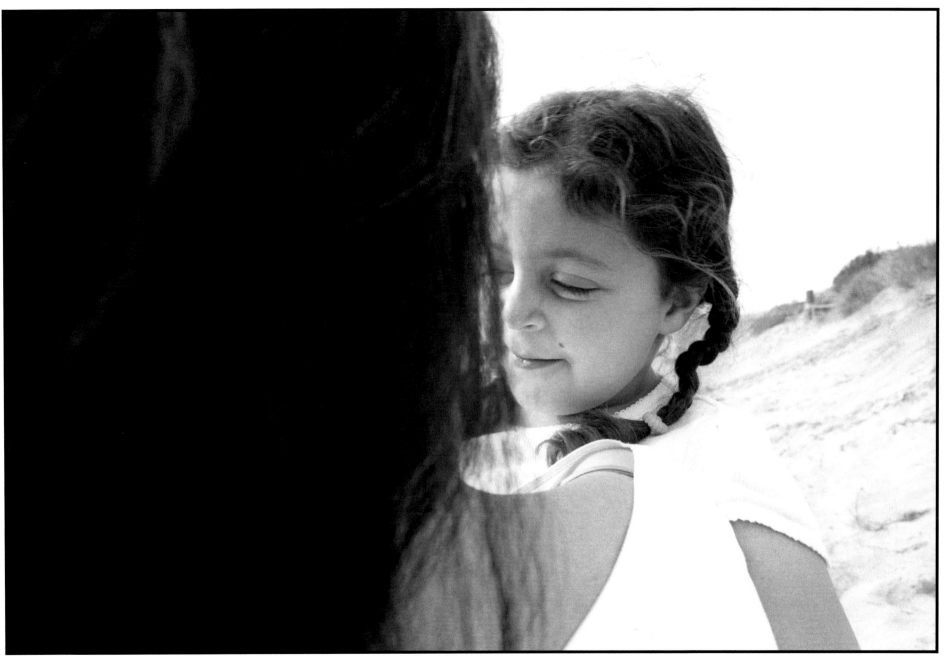

Lena's Glow

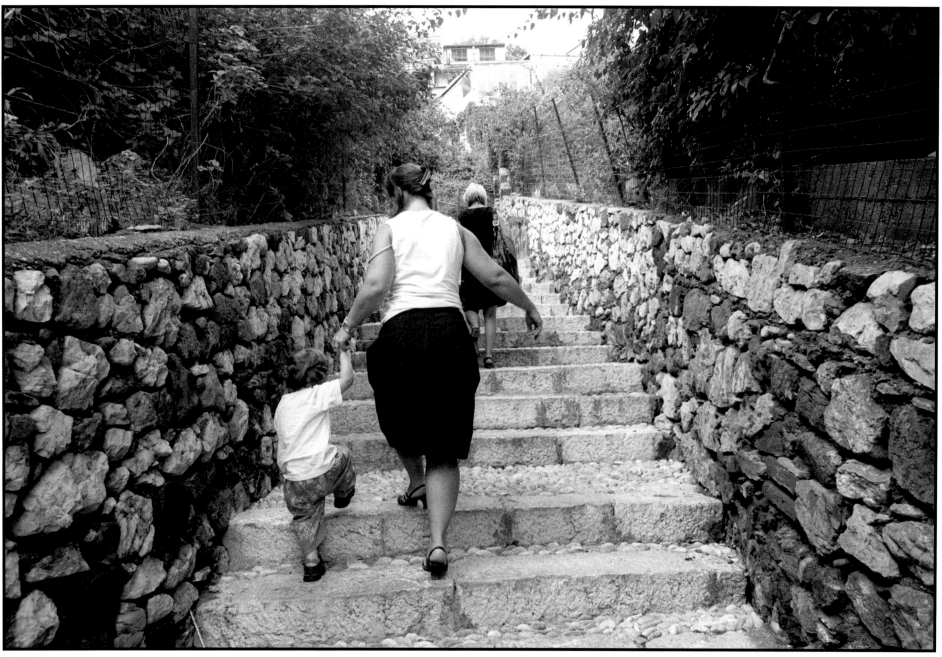

Help Up the Stairs

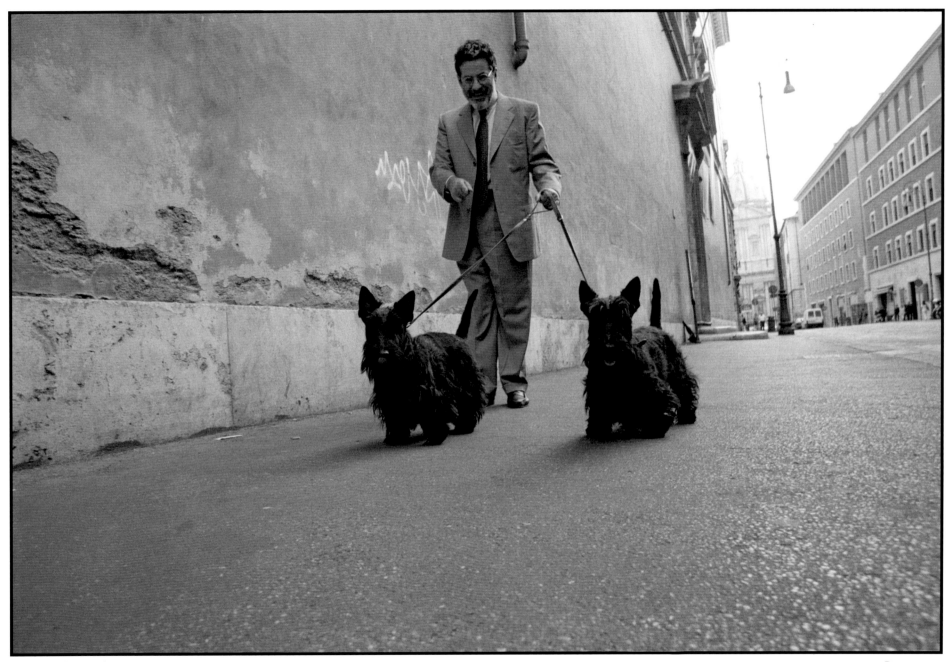

Walkies After Work

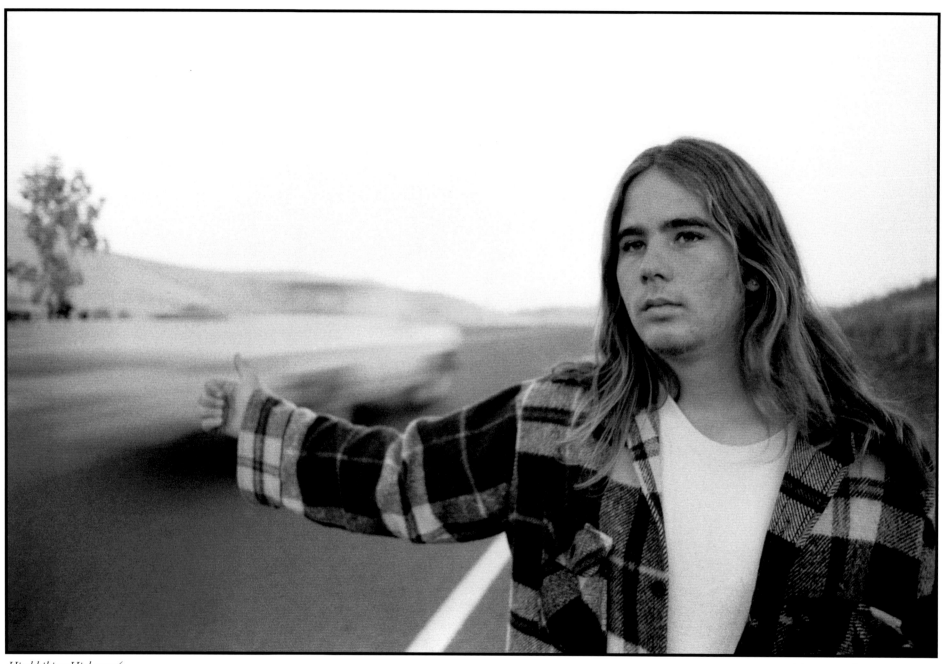

Hitchhiking Highway 4

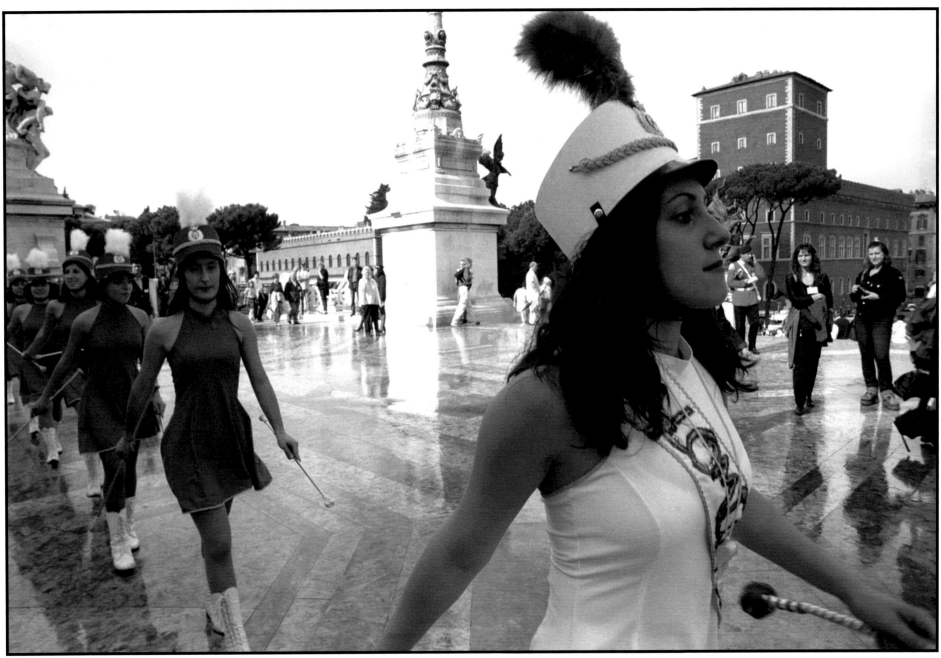

The Majorettes of Palombara Sabina

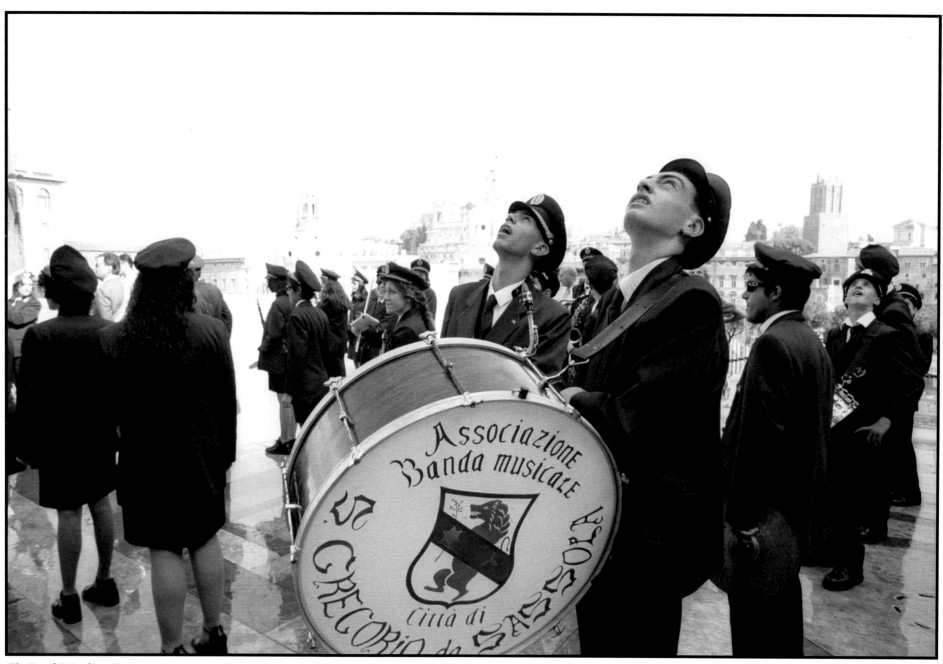

The Band Is Looking Up

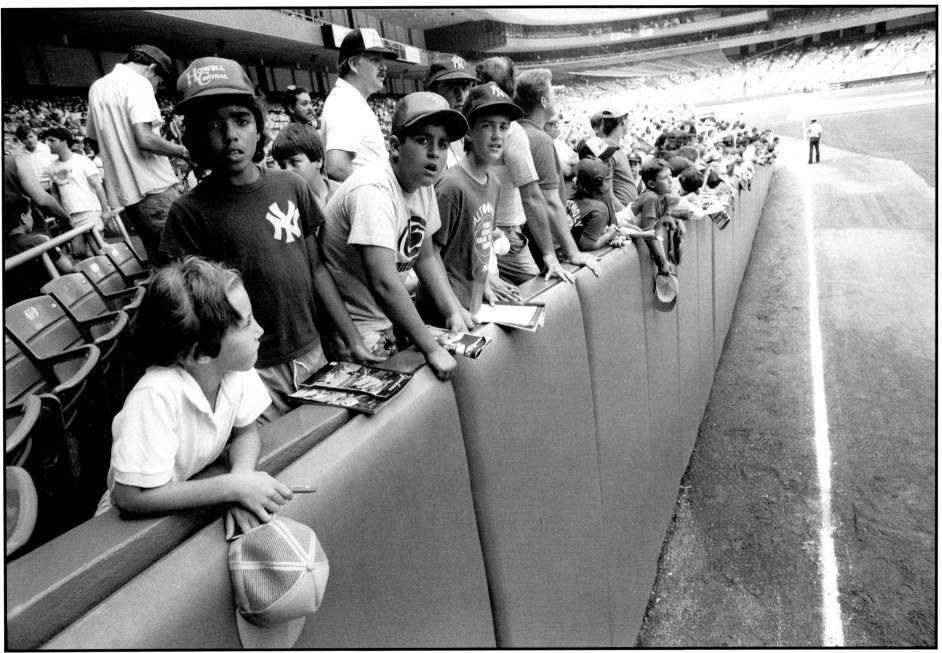

Autograph Seekers

YANKEE STADIUM, 2002

125

Miles Explores Dynamic Earth

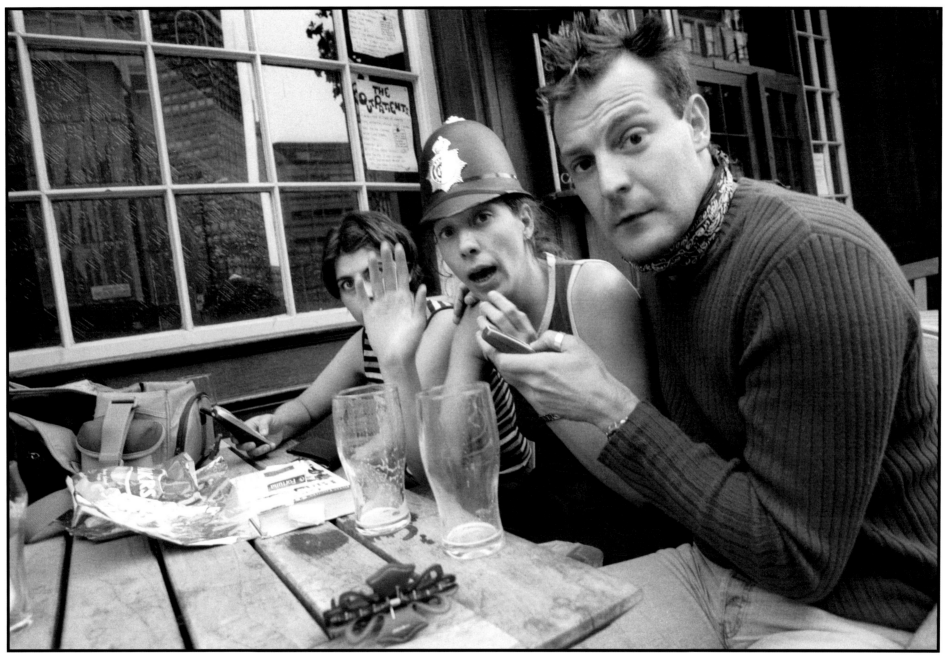

Startled Near Spitalfields

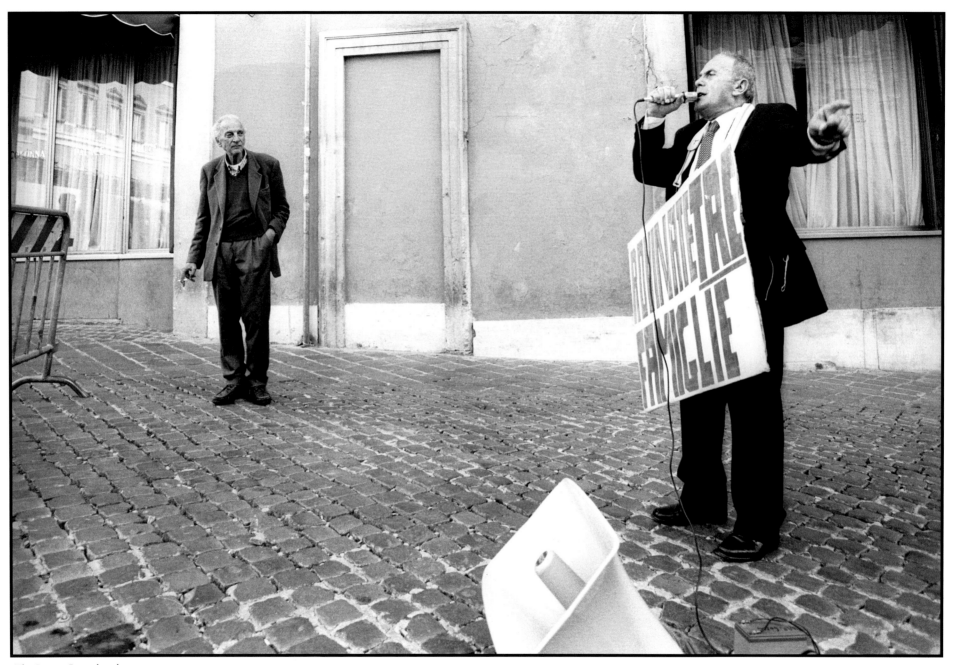

The Rant, Considered

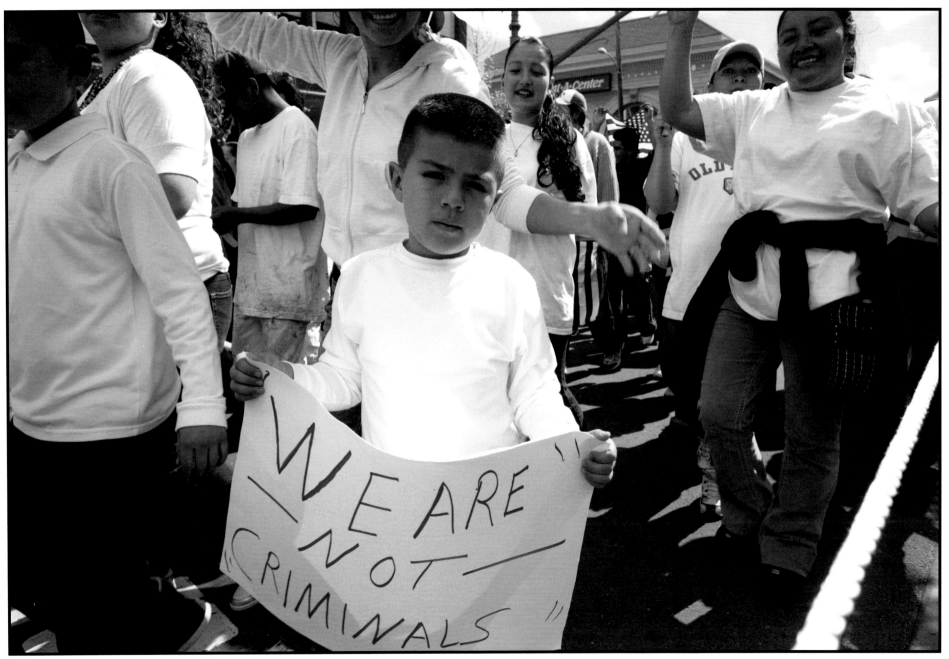

We Are Not Criminals

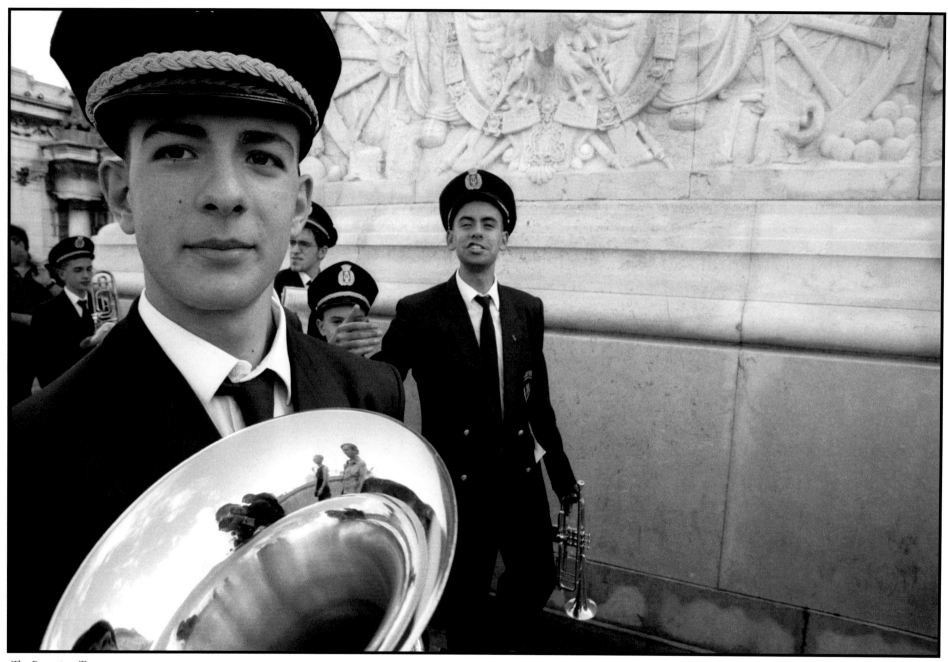

The Bragging Trumpeter

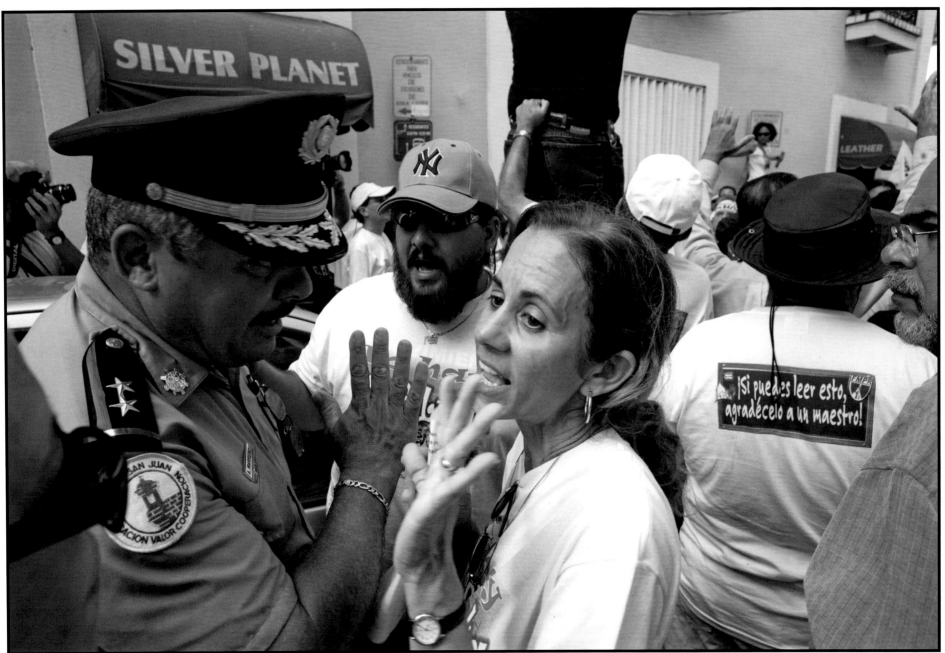

Negotiated Protest

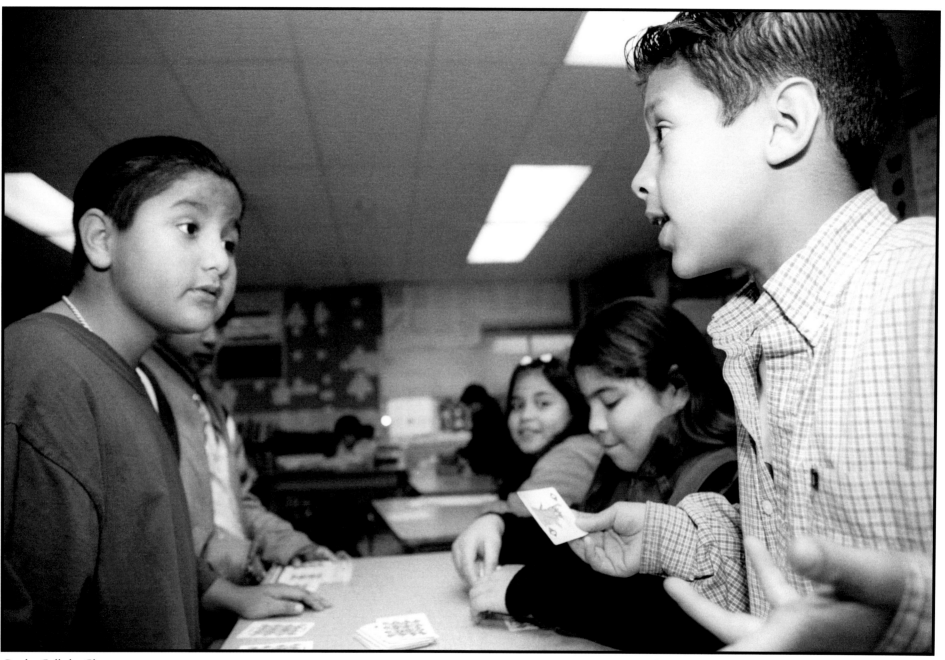

Dealer Called a Cheater

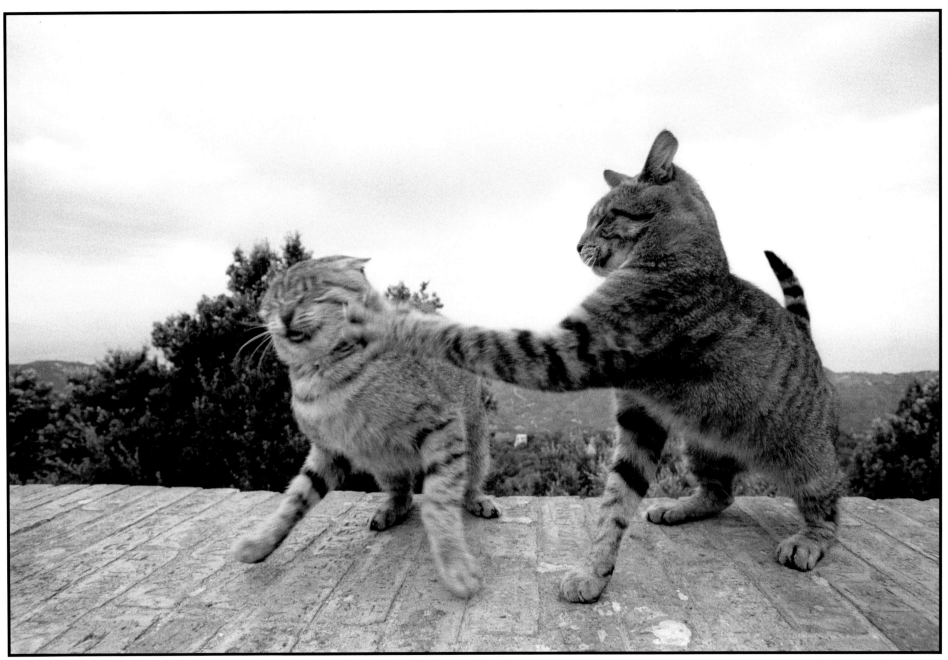

Cat Fight

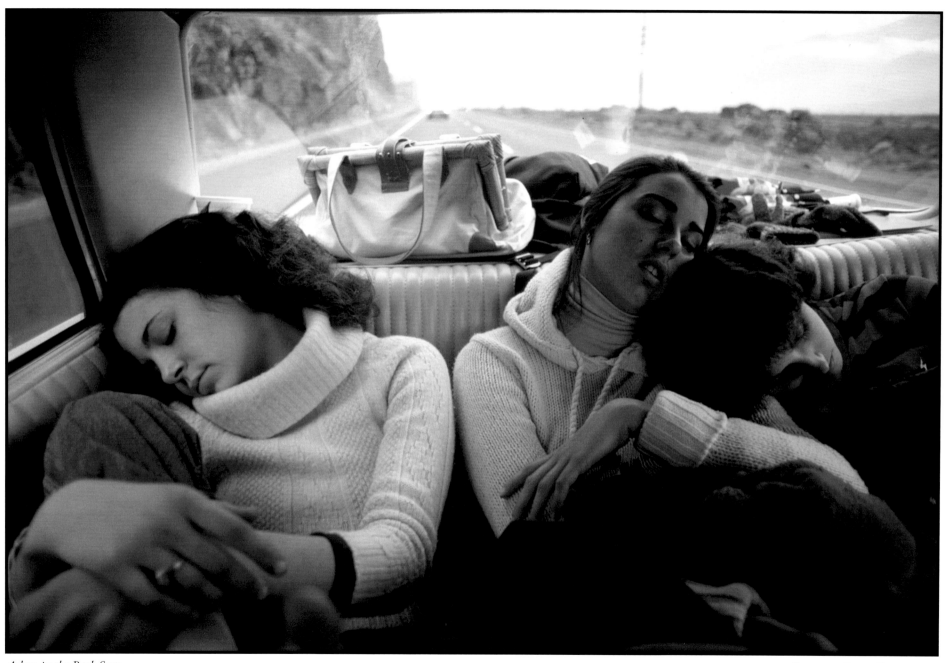

Asleep in the Back Seat

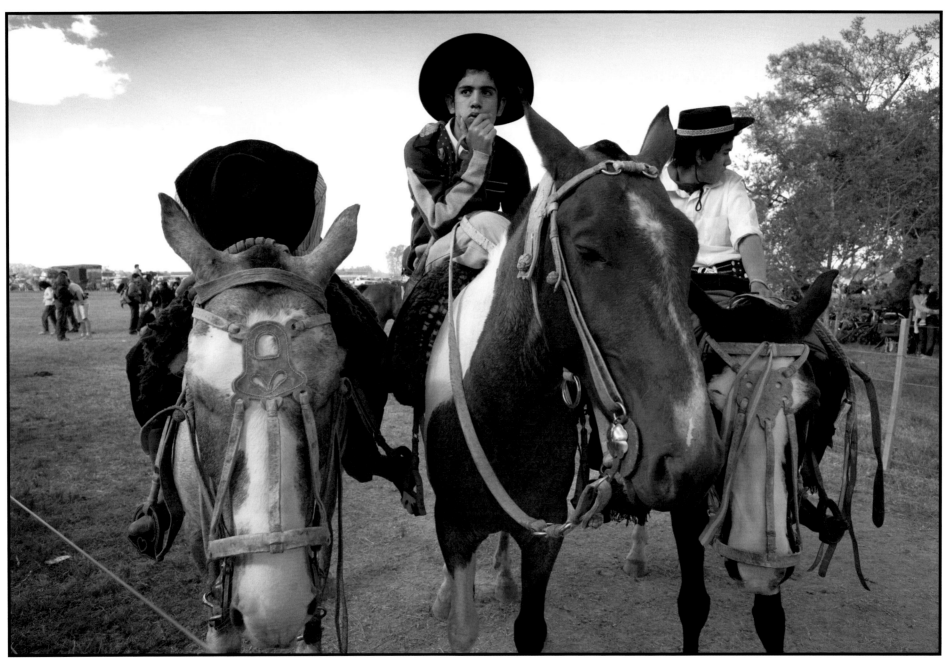

Long Day for Young Gauchos

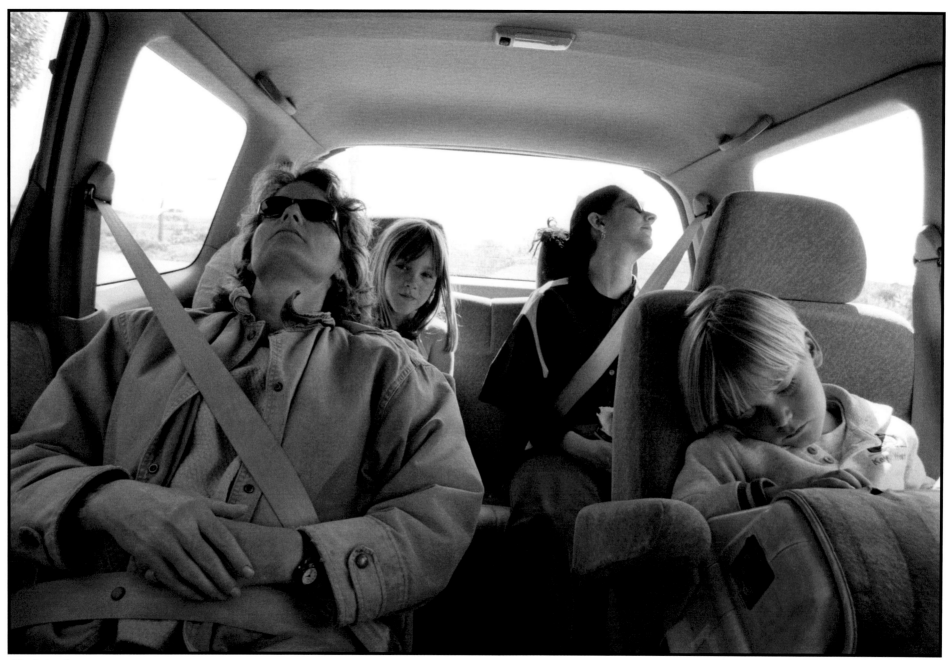

Shea's Awake

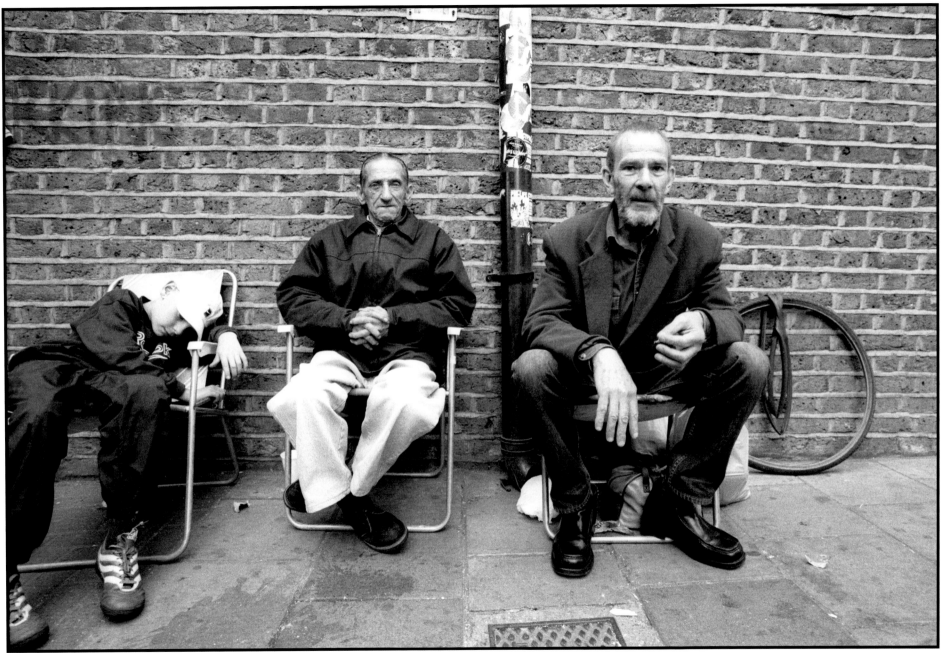

Sunday Inactivity

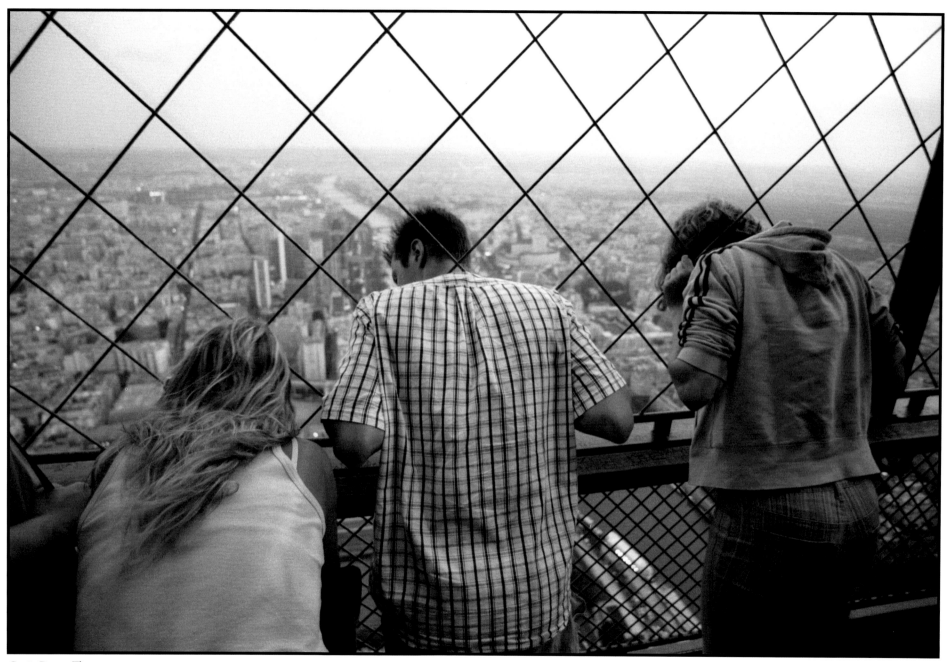

Paris Down There

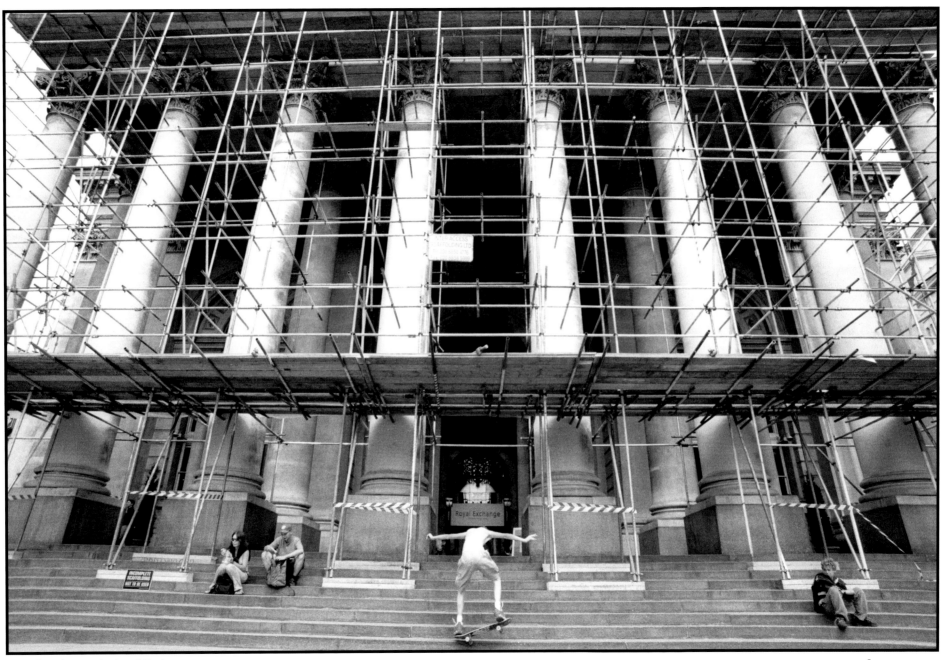

Skateboarding at the Royal Exchange

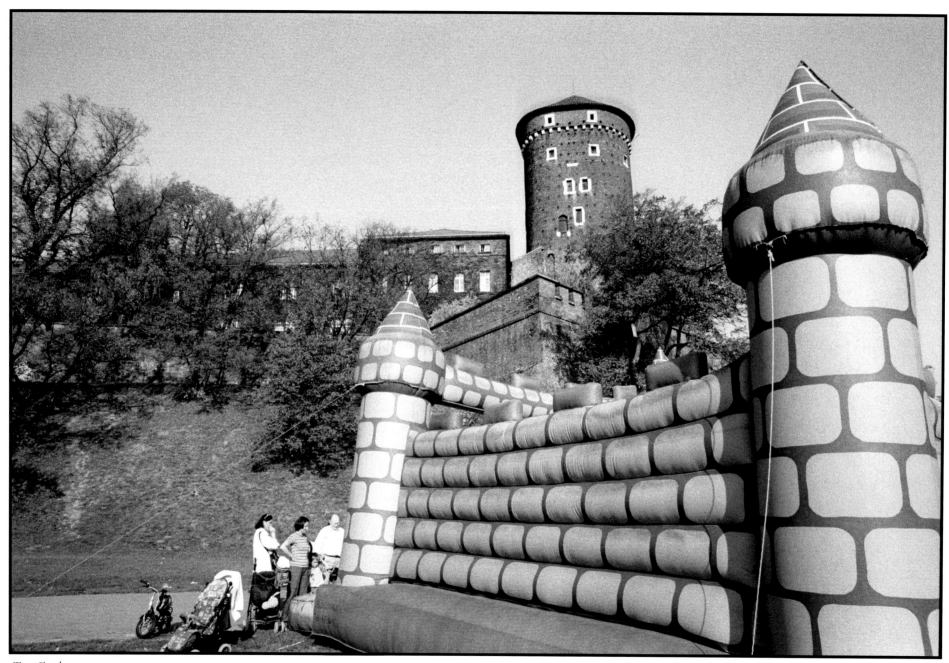

Two Castles

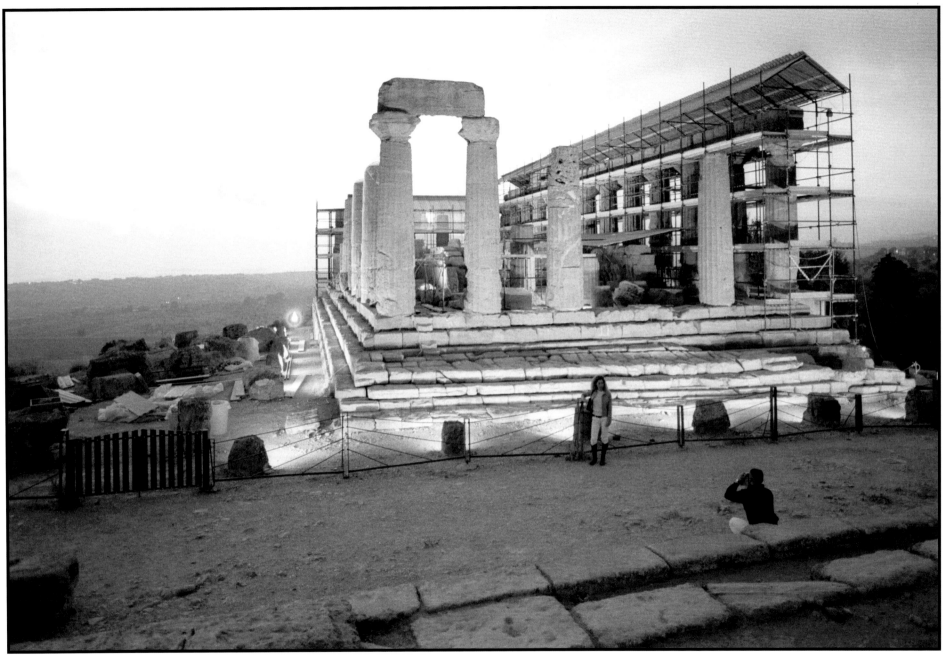

Posing with the Temple

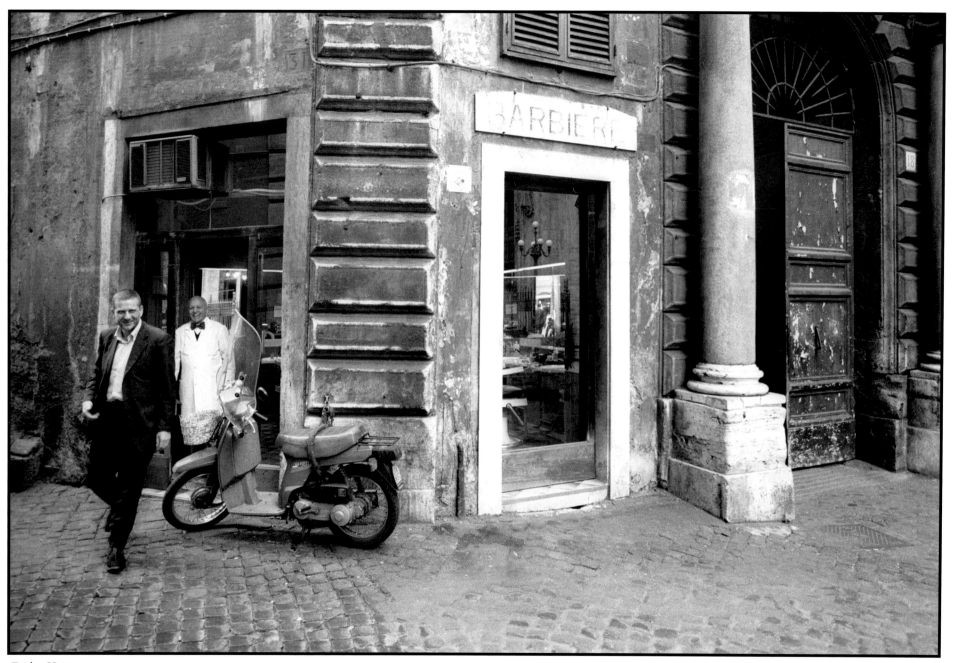

Friday Haircut

I was born in San Francisco in 1960, grew up in Martinez, California, and, except for a single year in Chico, California, I have lived my whole life in the Bay Area. I attended San Francisco State University, where I earned a bachelor's degree in creative writing in 1982 and a master's degree in American history in 1988. Then I taught for a while as an American history instructor at three different East Bay community colleges, before working in the legal field as a non-lawyer for a decade, followed by several years as an elementary school classroom volunteer. Employment-wise, I've done a lot of things, but I've never worked as a professional photographer.

And yet, despite far more education, training, and professional work with words, I've always been a much better photographer than writer. I learned pretty much everything I needed as a photographer at Alhambra High School in Martinez (Class of '78), and took it from there. For various reasons (which I still believe was for the best), I dropped my ambitions to be a professional photographer as soon as I hit college. I never took a college course in photography nor any kind of post-high-school photo workshop. Photography simply became my personal artistic outlet, and I didn't want any outside direction.

With photography, I've always emphasized two fundamentals: composition and timing. My sense of composition comes from the visual arts in general and landscape photographers in particular—most notably Ansel Adams and Edward Weston. Using their examples of how to place objects within a frame and what to do with light, I've tried to remain rigorous with my compositions. And yet, I compose almost unconsciously, finding vectors and patterns from the scene, grabbing horizontals and verticals, and lining them up in my viewfinder, quickly and efficiently.

That allows me to concentrate on timing, which I *also* don't concentrate on; I just let it happen—because timing is everything. Timing tells the story, specifically through the "telling moment," when relationships reveal themselves. To capture those telling moments, I've made use of my natural rhythm. I'm a drummer and a pretty good dancer. Situations have tempos, and I seem to have an autonomic ability to find the beats. I almost always hit on the upbeat, the "two" or the "four." That's when action is at its physical apex, which, emotionally, is the most *open* moment. So though my compositioning is influenced by photographers who use very, very, tedious, exacting methods, I'm a frame-a-scene, catch-the-moment kind of photographer.

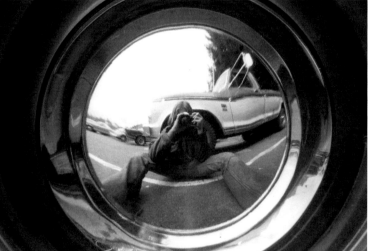

Hubcap Wide-Angle

MARTINEZ, CALIFORNIA, 1975

Few moments caught in this book were preceded by me announcing that I was going to take a picture or by my asking permission to do so. (Want to *not* catch a telling moment? Make an announcement beforehand.) In turn, few of these images came from anything but my engagement with ordinary life. Everything outside of the Bay Area I took as a tourist; almost everything else I took as a guest, friend, audience, or participant—out and about, among and interacting with the people in the frame. I'm a huge fan of classic, mid-Century photojournalism. It was the monumental 1955 photo book, *The Family of Man*, which I first discovered as a seventh grader in 1972, that made me want to be a photographer. And the book's contributors—the great *Life* and Magnum photographers, et al.—permanently shaped my photo sensibilities, as well as my personal philosophy. Most of what I do with a camera is self-assigned pretend photojournalism.

I shoot black-and-white, hand-held, 35mm. I use a wide-angle lens almost exclusively, so I'm usually at an arm's length—or conversational distance—from my subject. The wide-angle perspective is both optical and emotional: providing an *expansive* and *intimate* view at the same time, which I love for the "you are there" sense it provides the viewer.

Having thus been engaging optically and emotionally with the world around me for more than thirty years, I needed to finally put my favorite, most representative, interim results between covers. Choosing a theme around which to select my images was easy: "relationships" is what I'm always observing (as I assume most people do)—following life's little narratives or occupying one's mind by making connections.

Speaking of connections, I need to thank many, many people. But choosing whom to thank is a lot harder than choosing images for a book. I've never had an actual personal mentor behind my photography; in fact, I can only count one full-time professional photographer among my friends. Since the early 1970s I've had countless people in my life who are interesting and creative, consumers and/or practitioners of the arts, from whom I've received inspiration, knowledge, and encouragement. So, rather than attempt to name them all, forgetting many (or filling many pages), or point out particular people for particular gratitude, and invariably skewing the list to recent years, I'm going to just say that I have a lot of deeply satisfying relationships in my life; it is in their honor that I present **Relationships**.